Gabriele Bartolozzi Casti - Giuliana Zandri
Rossana Castrovinci - Elena Roio

T0145936

The Basilica
of San Pietro in Vincoli

edited by
Gabriele Bartolozzi Casti

Rome 2014

viella

The cover photo is by Mallio Falcioni

Layout and graphic design: Daniele Cesarini

Authors
– Gabriele Bartolozzi Casti [G.B.C.], pp. 11-37, 40-49
– Giuliana Zandri [G.Z.], pp. 37-39, 50-74
– Rossana Castrovinci [R.C.], pp. 75-88
– Elena Roio [E.R.], pp. 89-91; tables I, II;
 drawings, 1, 5, 5bis, 6bis, 7bis, 14, 16 a-b, 27, 31

Collaboration
Studio associato LIMES LAB engineering services
(G. Sola, E. Roio, L. Sovrano)
www.limeslab.com

viella
publisher
via delle Alpi, 32
I-00198-ROME
tel. 06 84 17 758
fax 06 85 35 39 60
www.viella.it

TABLE OF CONTENTS

General Description of the Area around San Pietro in Vincoli

Table I

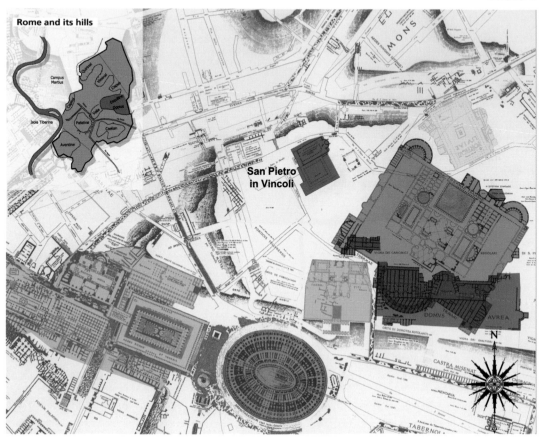

base R.Lanciani FUR tavv. 22-23-29-30, Elaborazione Arch. E. Roio 2013

Legend

■	San Pietro in Vincoli
■	The Baths of Trajan
■	Domus Aurea
■	Colosseum
■	Portico of Livia
■	Roman Forum
■	The Baths of Titus

Preface

"Give my greetings to Priscilla and Aquila, my fellow workers in Christ, ... and to the church that meets in their house"[1]. These are the words of Saint Paul in his epistle to the Romans. Of course, by church he did not mean a physical building but the community of the faithful. It is from Paul's expression that the term *domus ecclesiae* originated.

We have no way of knowing how many clandestine churches were meeting secretly in these *domus* or semi-secretly during periods when there was no persecution, but certainly the number tended to rise as time went on. Each one of them certainly had its own spiritual guide who was known as a *presbyter*, or what today we would call parish priest. It might seem odd to us, but these people were missionaries who were doing their work amid the splendour of imperial Rome. Their efforts were clandestine, but if necessary, they did not hesitate to declare themselves publicly to the imperial authorities, braving martyrdom in the name of the faith. Today we have a different idea of what a missionary is, one that often suggests distant countries, but every age has its own special features.

Even during periods when there was no persecution, however, Christians were not allowed to own buildings that could be specially used as churches. Under Roman law their communities had no legal standing and therefore they could not own property. So wealthy nobles,

Fig. 1. *The Façade. The late 15th century portico that substituted the previous, original narthex, while the upper floor was added the next century (1570-1578).*

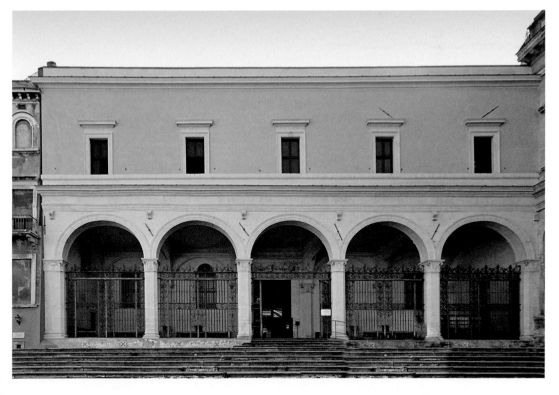

Archaeological Floor Plan of the Basilica of San Pietro in Vincoli

Table II

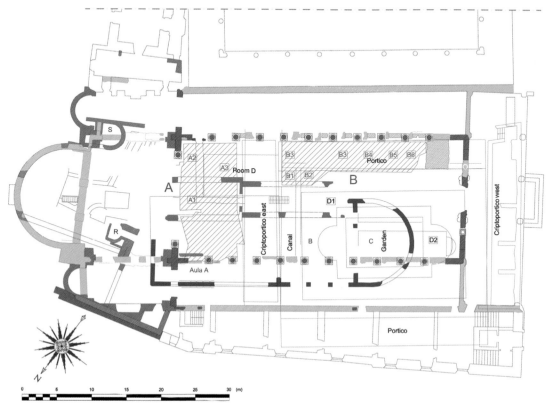

base G. BARTOLOZZI CASTI in Christiana Loca - Elaborazione Arch. E. Roio 2013

Legend

The Roman Domus

/////	2 Republican Houses 1st century BC. (A-B with mosaics)
■	Classical Remains (R-S)
▨	Imperial Domus 2nd century.
■	Domus apsidal hall second half of the 3rd century

Basilica

■	First construction end of 4th beginning of 5th century
■	Liturgical Enclosure
■	Church rebuilt by Sixtus III (432-440)
■	Renaissance additions

sympathetic to Christianity, accommodated worshippers in their own homes, posting the name of their *gens* over the front entrance (*titulus*) to show that it was private property and thereby affording protection. Important people who made their homes available included Pomponia Grecina, Acilius Glabrio and an entire branch of the *gens Flavia.* The practises that went on inside these *tituli* were much like those in our own parish churches, including the study of the catechism and performing works of charity. Paul himself in his epistle to the Philippians refers to Christians whom he calls *saints* because of the dangers they were risking within Caesar's very own house[2].

During the first decades of the twentieth century, an important scholar of Christian archaeology, Mons. Giovanni Pietro Kirsch, originally from in Luxembourg but who had spent most of his life in Rome, (see Chapter II), after conducting many studies, noticed that underneath every early Christian titular basilica there had existed older dwelling structures. We may suppose that these structures had special rooms set aside as "churches within the house" to borrow Saint Paul's phrase. This is also explained by the high cost of building materials inside the city of Rome. Certainly, the Christians were not rich enough to acquire real estate and so they took advantage of what their benefactors had already provided for free. In reality, proof of these arrangements, e.g. sacred images, has never been found, but the Christian faith was a clandestine one and the images might well have been used as evidence against them.

The *Liber Pontificalis* tells us that at the time of Anacletus (76-88), third successor to Saint Peter, there were 25 presbyters appointed by him. We cannot know if every one of these men was assigned to a place of worship, or if some of them were itinerant preachers, but one thing is certain: Christianity was spreading very fast.

After these general and preliminary remarks, let's go on to look at our glorious and beloved basilica.

Underneath the church important remains of Roman dwellings have been found. In particular, there is hall-shaped room endowed with an apse that suggests it was a space used for liturgical assembly. Unfortunately, we do not know the name of the generous donor. The person who actually constructed the Basilica proper was the great pontiff Sixtus III (432- 440) who entrusted the task of directing the construction work to the brave and indefatigable priest and presbyter Philip, a man dear to him: *labor et cura Philippi* recalls an inscription which at one time was to be found in the church. And so, Philip was the first rector of the basilica.

One of Sixtus' main aims was to build more places of worship and equip them with baptisteries so as to increase the number of the faithful. Besides our own church, he also founded Santa Maria Maggiore after the Council of Ephesus. Sixtus is not as famous as other popes, like

Leo the Great, but his spiritual and pastoral work was magnificent. In fact, Leo who succeeded him to the papal throne, was his archdeacon and pupil, and took Sixtus as a role model. Sixtus also endowed our basilica with a baptistery, though all that remains of it today is the monumental triple arched entryway, which we shall see in the following chapters of this book. Inside the basilica, among the ancient relics conserved we are most grateful and duty bound to mention the chains of the Prince of the Apostles, from which the church takes its name and which make it the city's second most important site for the Petrine cult after the Vatican basilica. And among its great works of art is the splendid mosaic of Saint Sebastian and the tomb of Julius II with Michelangelo's Moses which certainly does not need any praise from me.

This titular basilica has always had cardinals of outstanding stature. There were the great humanists, theologians and canonists: Nicola Cusano and Jacopo Sadoleto. We must also mention the members of the della Rovere family who did so much for the decoration of the church: Francesco, Giuliano, Galeotto Franciotti della Rovere, Sisto Gara della Rovere, Leonardo. Of these the first two became popes Sixtus IV and Julius II respectively. Certainly Sixtus IV assumed the name in honour of and for spiritual continuity with our church's great founder Sixtus III. We should also mention that it was in San Pietro in Vincoli that Gregory VII was elected pope and that here Giovanni Maria Mastai Ferretti, the future Blessed Pius IX was appointed bishop of Spoleto.

During the painful period of the Second World War the See remained vacant until the appointment of cardinal Teodosio Clemente de Gouveia in 1946 who was followed by Leo Josef Suenens, Jean Marie Jiulien Balland, Louis-Marie Billé, Pio Laghi, predecessor of our beloved Donald William Wuerl whom all of us wish the very best and to whom this guidebook has been dedicated.

I think it fitting at this point to hand the reader over to this outstanding group of scholars who together will illustrate the story and art treasures of our basilica in the coming chapters.

Don Bruno Giuliani
Rector

I. The Church's Site

Three summits crown the Esquiline hill: the Oppius, the Cispius and the Fagutal. It is upon this last-named that the basilica of San Pietro in Vincoli stands. On the Esquiline were located villages of one of ancient Rome's original ethnic groups, the Albans. In close proximity to the church the following are situated, to the North-East: the Portico of Livia; to the South: the Baths of Trajan; the *Domus Aurea,* the sprawling residence built by Nero after the fire of AD 64; the Baths of Titus; the Flavian Amphitheatre (Colosseum) and west of it the Roman Forum. Table 1 shows the general archaeological layout with the basilica marked in red in the centre. Figure 2 shows the site as it is today.

The area was one of high prestige and home to a number of public buildings and rich houses or *domus,* but to the North on the left side of the church the hill slopes steeply down towards the poor neighbourhoods of Argileto and Suburra in the area around the present day via Cavour where these old names still survive in modern toponomy.

Fig. 2. *Site of the current basilica of San Pietro in Vincoli with neighboring streets.*

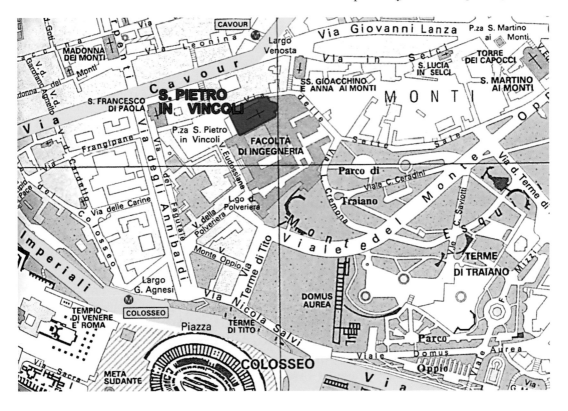

II. The Buildings that Preceded the Church

As in nearly all the titular Roman basilicas (parishes), underneath the Church there exist remains of private houses that were more or less upper class dwellings (*domus*). These places, very widespread, have given rise to the theory that Christianity was practised clandestinely in these residences during times of persecution. In other words, these homes are thought to have been the well known domestic churches (*domus ecclesiae*) where the first Christians gathered to pray.[3]

The archaeological discoveries first came to light during restoration of the basilica's baked brick floor which was carried out between 1957 and 1959. The excavations were conducted by Antonio Maria Colini with the participation of Guglielmo Matthiae for the Paleo-Christian part.[4] The restoration had been preceded in 1956 by underpinning work after the construction of nearby galleries for the subway.

Our church is remarkable because it is built over many archaeological strata that run from the Bronze Age to the 4th century AD. Out of this varied palimpsest of layers we shall be looking at the most essential and significant features - especially the phases and archaeological structures that are related to the later place of worship. In fact, as was the custom in Antiquity and late Antiquity many remains were reused to provide the foundations of the basilica. The various archaeological phases, including the basilica are shown in Table II.

II. 1. *The Republican* Domus

At the lowest level at least three Republican houses or *domus* were found which date to the 3rd-1st century BC. It is impossible to reconstruct what they looked like, but from the surviving floors adorned with small and highly prized mosaics we can deduce that they must have been very elite residences. The oldest of these *domus* are all situated entirely below the central nave, between the eighth inter-columnar section and the pillars of the triumphal arch (Floor plan in Fig. 3. Letter A). The later houses were made up of at least five rooms that stretched between the first and seventh column of the right hand colonnade (Fig. 3. Letter B). Figure 4 shows a photograph of the passage threshold connecting rooms B3 and B4 which is particularly refined and has been interpreted as reproducing a turret motif.[5] The floors were made of *opus signinum*, (waterproof compound) decorated with large irregular black and green tesseras and small white tesseras (today we would call this a Venetian floor). Figure 5 is a portion of this floor adorned with a refined wave motif that had at its centre an *émblema* (literally "an insertion"; the central framed figural panel of a mosaic floor) that was probably removed for reuse when work began on the building above. In the background of Figure 5, in fact, we can see an additional wall belonging to an unidentifiable structure which

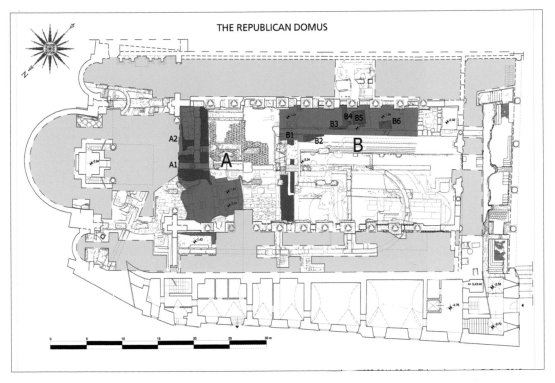

THE REPUBLICAN DOMUS

Fig. 3. *Plan of the Republican* domus *in relation to the basilica's floor plan.*
Drawing by E. Roio.

Fig. 4. *Mosaic threshold in small* tessere, *passage between rooms B3 and B4 on the floor plan in Fig. 1 Republican age.*
Photo by G. Bartolozzi Casti.

Fig. 5. *Section of the floor in zone B in fig. 3, in* opus signinum *in the centre a mosaic panel damaged by the removal of the emblem. Republican age. Photo by G. Bartolozzi Casti.*

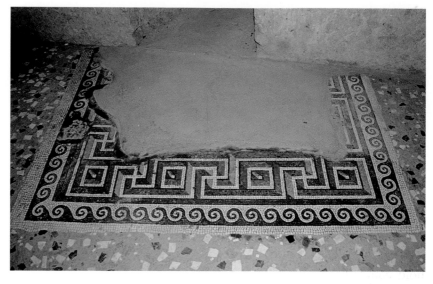

Fig. 6. *Mosaic panel of zone B in Fig. 1, damaged by the removal of the emblem. Republican age. Photo by G. Bartolozzi Casti.*

appeared before the imperial *domus*. In figure 6 the mosaic panel of room B5 is likewise missing the emblem that would have once stood at its centre.

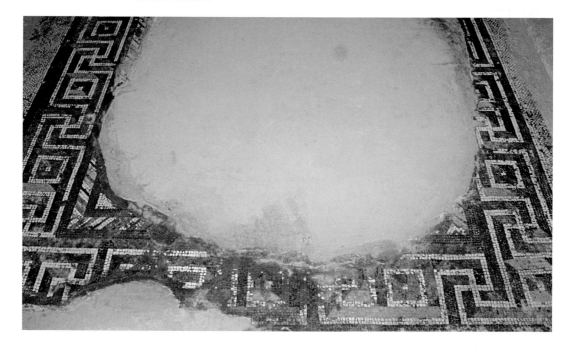

II. 2. *The Imperial* Domus

During the 1st century AD. these houses were destroyed and re-placed by a wealthy and refined *domus* which over time went through various phases but reached its highest splendour in a period whose general style and building technique date it to the reign of Hadrian. Of this house, which originally must have been much larger, the remains

of the important central area have been recovered. These traces have made it possible to distinguish and graphically reconstruct the complete floor plan (Fig. 7). As can be seen from the image, the house was made up of a large rectangular courtyard, flanked by two colonnaded porticoes on the longer sides. The dimensions are 28 x 20 m. The long axis coincides with that of the future basilica. Inside, in splendid alternation, a rectangular canal waterproofed with blue *opus signinum* surrounded the length of a green flower bed 22.5 x 15.5 m at whose centre was a basin, also blue with another flower bed. In our floor plan we have tried to reproduce the alternating colours of green and blue. It is not hard to imagine the refined taste that inspired the courtyard. We can find a comparable structure in Hadrian's Villa in Tivoli.[6] Below the short sides of the garden two crypto-porticoes were discovered; that is, two long rooms dug under the level of the *domus* and covered in places with air intakes known as *wolf's mouths*, where members of the household could discuss various topics in the hot season refreshed by the cool air.

Two rooms faced onto the east side of the porticoed courtyard. A large one (Figure 7, letter A) on the same axis as the large courtyard, whose floor was made of rectangular Carystian green (*cipollino*) slabs. The other beside it, smaller (letter D) with a triangular mosaic floor had a service function. Probably these areas predated the splendid porticoed courtyard which we have reproduced in perspective in Figure 7bis for the reader.

Fig. 7.
Reconstructed Floor plan of the imperial domus with porticoed courtyard and fountain-garden. Drawing by E. Roio.

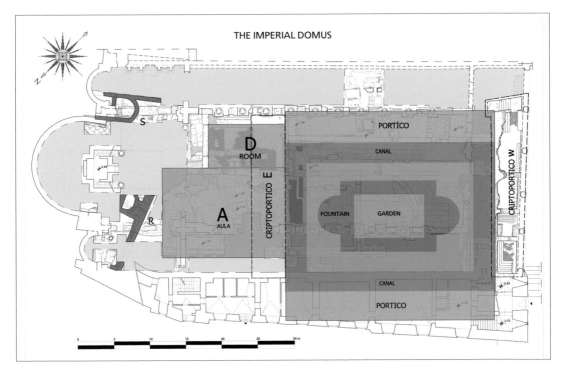

Fig. 7bis.
Reconstruction in perspective of the imperial domus *in fig. 7.*
Model E. Roio.

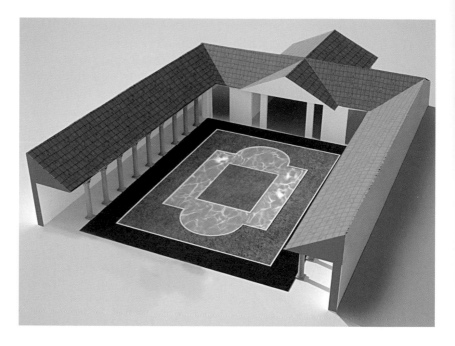

II. 3. *The Apsidal Hall*

Between the late 3rd and the early 4th century the residential complex underwent a series of transformations that radically altered its profile. First was the decision to enlarge the size of hall A in Figure 8 by adding extension B to it which is almost square and on whose sides two wide triple arched openings were made. A further modification was the introduction of the deep apse C, above the semi-circle, as wide as the hall (10.5 m) and 7.33 m deep. The result was the creation of a great hall with an apse. Unfortunately this meant the disappearance of the lovely basin and garden and the disfigurement of the porticoed courtyard (see three dimensional reconstruction of the hall in Figure 8bis).

The process of transformation just described we can consider as having been concluded not before the period of the Tetrarchy. It is an excellent illustration of the transition from classical age *domus* to one of late Antiquity. The apsidal hall, of which that in San Pietro in Vincoli is a typical example, is the clear sign of changing tastes and habits that were reflected in the *domus* of late antique Rome.[7] This new type of building stood at the centre of the ceremonial and social life of the *dominus* and his family. Its creation meant the unhesitating elimination of the lush green basin with its blue background. In the case of our church, when the Christian community was in a position to build the basilica, very likely it had already come into possession of the *domus* as a donation by a wealthy Christian owner or someone sympathetic to Christianity, as happened in numerous other cases. We cannot rule out the possibility that the apsidal hall– and the idea does not seem too far fetched in view of its design – was already being used for Christian

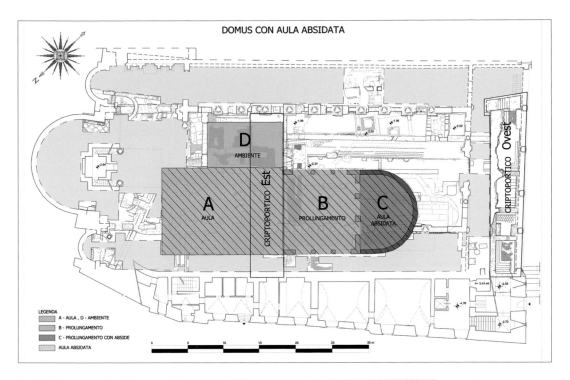

Fig. 8.
*Reconstructed plan
of the
apsidal hall
added to the
imperial domus.
Drawing by E. Roio.*

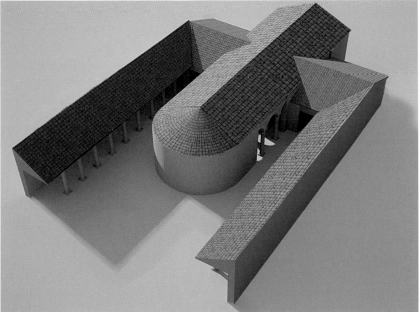

Fig. 8bis.
*Reconstruction in
perspective of the
apsidal hall
in fig. 8.
Model E. Roio.*

worship before the construction of the church (Matthiae). This well
founded theory takes us all the way back to the origins of Christian
worship in Rome, in private homes mentioned in the Preface with ref-
erence to Saint Paul's epistle to the Romans.

III. The Early Christian Basilica

The interior of the church had inscriptions on its walls that provided important information about the building's earliest history. For example, they indicated that its original name was *Titulus* or *Basilica Apostolorum*; that the church had undergone reconstruction and the identity of those in charge of this work. The inscriptions also mentioned the intervention and financial support of imperial patrons. Lastly, they even attested to the existence of a now lost mosaic scene that adorned the rebuilt church. The inscriptions themselves no longer survive, but fortunately as in the case of many Roman churches they were copied in the seventh and eighth centuries by literate pilgrims and included in collections called *syllogai*. Many of these compilations, of inestimable value, have survived to the present day in the form of codex manuscripts that were published by Giovanni Battista de Rossi in the second half of the nineteenth century.[8]

III. 1. *The First Construction*

The inscriptions do not tell us anything about the period of the first construction, nor about who commissioned it. By analyzing the techniques used in building the walls, and by comparing surviving architectural features we can estimate that construction took place in the early 5th century, or even at the end of the 4th. The building's design was common among post-Constantinian basilicas: a central nave and two lateral aisles separated by columns, an apse whose diameter was the same as the central nave and without a transept. The dimensions were remarkable. In fact, the total measurements, including the apse were 61 x29 m. Each of the colonnades separating the lateral aisles comprised 15 columns.

In addition, the church also possessed a particular trait that it shared with a few other Roman basilicas (from five to seven): the so-called open façade. This architectural feature is composed of a series of five entry arches with no separating doors that closed it off.[9] Other openings in the upper level were the five round windows, not aligned, with the central window being the highest. This type of façade was perhaps designed to provide the worshippers with a sense of an all embracing welcome, but the other examples of the time did not last long and before the middle of the fifth century they were all closed in. Our open façade may still be distinguished from inside (Fig.9 is a photograph of what it looks like today and in 9bis the graphic reconstruction). In fact, two column bases have survived at the level of the floor; higher up extensive zones of masonry in *opus latericium* and sectors with filled-in arches; further up four circular windows; the fifth and central one was transformed into an ellipsoid during the Renaissance. All of them, naturally, have been filled in.

Another feature that was rare in Rome but very common in Ravenna was the presence of windows in the lateral aisles. This is a rather recent

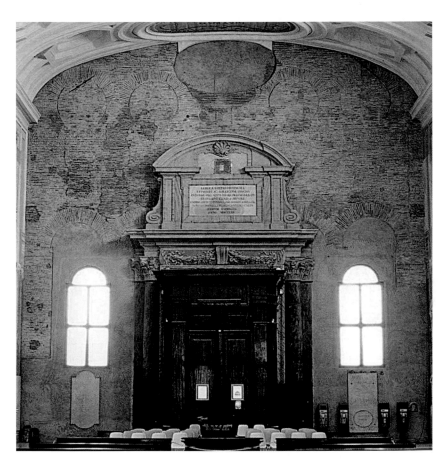

Fig. 9. *Image of the façade taken from inside the Paleo-Christian basilica. Photo by G. Bartolozzi Casti.*

Fig. 9bis. *Reconstruction of the first, so-called open façade of the Paleo-Christian church. Drawing by E. Roio.*

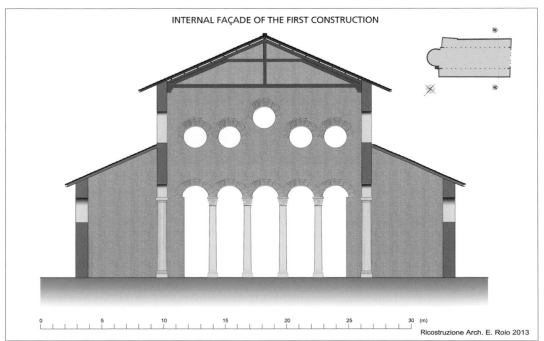

INTERNAL FAÇADE OF THE FIRST CONSTRUCTION

0 5 10 15 20 25 30 (m)

Ricostruzione Arch. E. Roio 2013

discovery which emerged during the restoration work in the cloister of the monastery, which today is the location of the Engineering Faculty.[10]

Segments of the arches of these windows may still be seen from the cloister. During the same restoration three large arches emerged which we shall deal with in greater detail below (Fig. 10).[11]

For economic reasons building materials were taken from the remains of the earlier construction or *domus* and used as a foundation - not an unusual practice at the time. However, in our case these remains proved to be unsuitable because of their lack of homogeneity so that the basilica's axes never cross at right angles. The asymmetries are clearly noticeable by looking at the floor plan (Table II). The situation, quite understandably, negatively affected the building's stability, also because of its great size. After a few decades this led to instability and collapses.

Fig.10. Remains of the three closed in windows of the North aisle and the large triple arcade (triforio) accessing the Paleo-Christian baptistery. Photograph by G. Bartolozzi Casti.

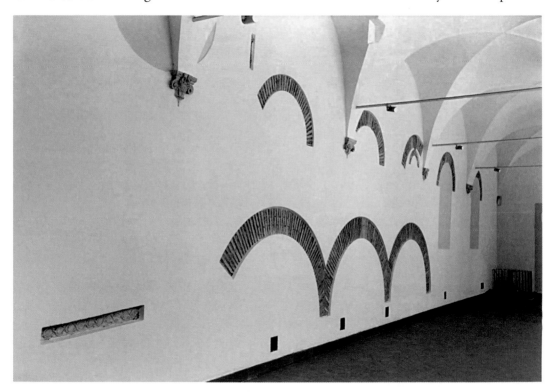

III. 2. *The Church Rebuilt*

The reconstructed building occupied the same area as the one that preceded it, except for a few differences which we shall see, and it was the same size, but its structural alterations were considerable. According to the inscriptions mentioned above, it was Sixtus III (432-440) who ordered the reconstruction. Sixtus deserves considerable praise for having built churches, including Santa Maria Maggiore in homage to the Blessed Virgin following the decisions by the Council of Ephesus (431) to proclaim Mary the "Mother of God" (*Theotòkos*) and not merely the

"Mother of Christ" (*Christotòkos*), in opposition to the Nestorian heresy which denied that the Son had the same, unique and indivisible substance of the Father. Sixtus also reconstructed the Lateran baptistery. In our church the job of overseeing the works was given to the competent and deserving parish priest and presbyter Phillip whose name was duly recorded in one of the inscriptions (*labor et cura Philippi*).[12] This skilful ecclesiastic had even represented Sixtus' predecessor Celestine I at the Council of Ephesus in 431.[13] The eastern emperor Theodosius II and his wife Aelia Eudokia pledged their financial support for the project, and subsequently the couple's vow was kept by their daughter Licinia *Eudoxia*, who had married the western emperor Valentinian III *(votum [...] Eudoxia nomine solvit)*.[14] In fact, the basilica was also given the name Eudoxian at least from AD 600 at the time of Gregory the Great.

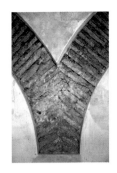

Fig. 10, detail. *Intersection of the triforio arches. Photograph by G. Bartolozzi Casti.*

Doubtless, the renovations were undertaken in order to make the building more stable, but its internal and external perspective views were also altered.

The pillars on which the base of the columns rested were replaced with others that were wider and stronger. These were set alongside the old columns lengthwise following the original alignment of the old colonnade. One of the old unused pillars is still visible in a transparent surface on the floor beside the sixth column of the right hand colonnade (South, fig. 11).

An important innovation was the introduction of the transept. This architectural feature, which may be found in Constantinian and later churches, is a transversal nave that crosses the others at right angles meeting them at the juncture point with the apse, that is, at the point where the building is weakest. This intersection significantly increases the building's stability. In addition, it gives the floor plan the shape of a Latin cross which has often been thought to have a Christological meaning. The transept we are speaking about had two windows on the upper part of each of the far walls– of these only the two on the North

Fig. 11. *Base of the previous column and the new column. Photograph E. Roio.*

side have been preserved – the whole structure must have been rather bright. The interruption in the lengthwise extension of the nave, caused by the addition of the transept, reduced the number of columns from fifteen to ten per side, all of them preserved. They are in the Doric style of white Parian marble with grey veins, 6.2 m high and all of them alike. This is a very rare occurrence in early Christian churches, since they generally employed a variety of recycled materials. As to their origin, none of the theories is convincing.

Table II shows a graphic reconstruction of the church's floor plan based on the archaeological remains and it is basically the same as the current one. In it we can clearly distinguish the asymmetries referred to above, particularly the oblique angle of the extremity on the left side (North) of the transept and that of the apse which did not possess windows (the current ones are from the Renaissance). As regards the transept's outer terminal walls, the obliquity was caused by reusing the base of a pre-existing wall as a foundation which itself was influenced by the inclination of the end of the hill where it slopes steeply downward to the area below and via delle Sette Sale.

The basilica was also endowed with a liturgical enclosure, that is, a corridor running down the centre of the central nave marked out on the floor and slightly raised. It was used by the clergy and papal processions on important occasions. Just past the halfway point the corridor widened out towards the lateral aisles, to make room for the *cantores* of the choir.

The apse was also built using materials from pre-existing buildings. One could say that after it was reconstructed the building did not create any further serious problems with the exception of the apse itself, in spite of the precautions taken, like erecting a great masonry pillar at the extremity of the southern terminal in order to resist the dragging action caused by the hill's slope where today via delle Sette Sale runs and a brick "chain" under the floor that connected the extremities.

Like all the most important churches ours had an attached monastery whose clerics took part in the titular church's services. The *Liber Pontificalis* mentions the existence of a monastery of Sant'Agapito *ad Vincula*, which disappears from the documents after the 8th-9th centuries. Instead we find a Santa Maria in Monastero *ante venerabilem titulum Eudoxiae* which likely was a change of name, perhaps connected to renovation work.

San Pietro in Vincoli was included in what was known as the stational system of papal processions that succeeded each other during the entire liturgical year. The procession which started out from Sant'Adriano in the Forum Romanum, the first gathering place, made its way down the Via dell'*Argiletum* (today Via della Madonna dei Monti), made a detour uphill towards the top of the Esquiline hill to include our basilica and finally reached Santa Maria Maggiore where the main celebration was held (*statio*).

III. 3. *Medieval Interventions*

From the *Liber Pontificalis* we know that work was done by Adrian I (772-795) but no archaeological trace of this has been found, with the exception of the two little pilasters or architraves that are currently inserted into the external part of the basilica's northern perimetral wall (figs. 12 and 13)[15]. They show features from the Carolingian period and may have had something to do with the holy vessels of the baptistery, which we shall see in the next chapter IV. Of the baptistery, all

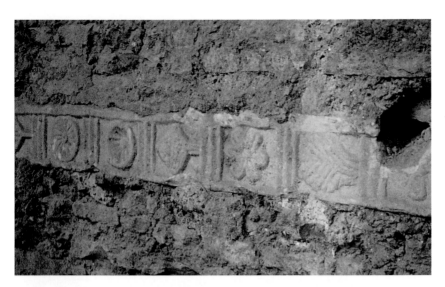

Fig. 12. *Carolingian pilaster walled into the external northern perimeter of the basilica Photograph by G. Bartolozzi Casti.*

Fig. 13. *Carolingian pilaster walled into the external northern perimeter of the basilica Photograph by G. Bartolozzi Casti.*

that remains are the upper portions of the arches belonging to the monumental triple arched entryway.

On the outer part of the apse, higher up, numerous renovations and repairs may be seen in the walls. At the mid-upper level a vast work of integration can be distinguished in imitation of the original (fig.14). The coping is clearly Romanesque characterized by bricks laid in a serrated arrangement and closely recalling that of the upper Church of San Crisogono (1123-1129),[16] an unmistakeable reference for the date of intervention on our own church: the resemblance is so great that the work would appear to be that of the same masters.[17]

Evidence of other problems are the traces, still visible, of a big crack found over the highest terminal section of the right transept which is missing: it was probably threatening to collapse and it was decided to get rid of it and with it the two windows over the headpiece also disap-

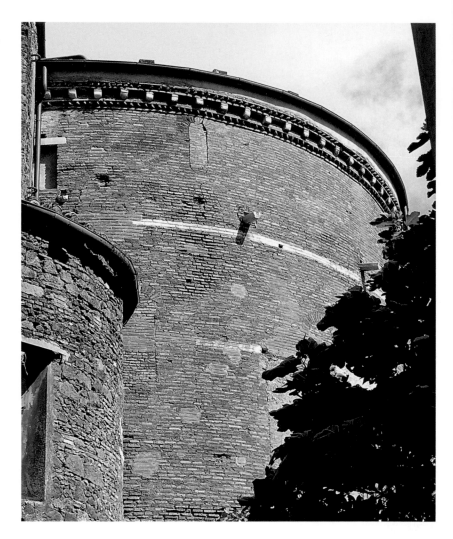

Fig. 14. *External part of the apse with Romanesque additions (first half of the 13th century). Photograph by G. Bartolozzi Casti.*

peared. This situation led to the insertion of two powerful arches out of squared ashlar blocks between the tops of the colonnade's concluding pillars and the upper extremities of the apse that rose over the transept. Of these two arches only the one on the right (North) survives. Before the construction of the Della Rovere vault the arches were visible from below. In figure 15 the surviving arch supports the medieval wall that is closed on the outside. This wall contains three arched windows, the two smaller side windows and the larger central one, placed there in order to provide good illumination. The wall is decorated with a beautiful false curtain painted in a serrated pattern and at the centre a sort of pinwheel representing a heavenly body in rotation. The accurate workmanship of the arches along with the execution of the false curtain, rather refined and ornate, suggest the work was done in the 13th century,[18] perhaps around the midway point. The next important change took place after the period when the papacy was in exile in Avignon during which time,

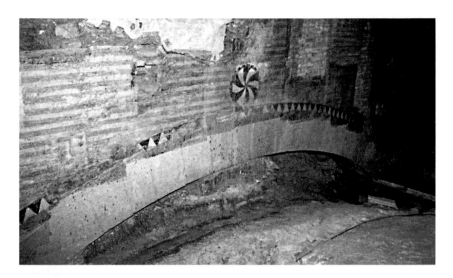

Fig. 15. *Medieval arch in stone ashlar blocks support between end pillar of the northern colonnade and the upper extremity of the apse.*
Note the lovely wall decorated by a false curtain that the arch supports.
Photograph by G. Bartolozzi Casti.

of course, no one bothered about the basilica and the roof was in very poor condition. In 1448 Nikolaus Kraus Krebs from Kruess near Trier was appointed titular cardinal of San Pietro in Vincoli. Also known in Italy as Nicola Cusano, he was a great churchman, theologian and man of letters who not only commissioned artistic works, but also had the roof of S Pietro in Vincoli rebuilt. One of the beams with his name carved on it was exposed in two separate sections, on the windowed wall on the right above the colonnade (fig. 16).[19]

Fig. 16. *Wooden beam, exposed above the northern colonnade, bearing the name of Nicola Cusano.*
Photograph by G. Bartolozzi Casti.

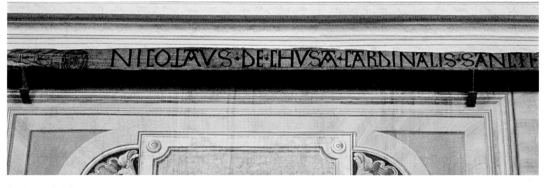

IV. The Baptistery

During work on the cloister of the monastery, which we discussed in connection with the windows in the smaller aisles, three arches emerged which were much wider than the others and joined together lower down (Fig. 10). The three arches comprised the upper part of a monumental triple arched passageway (*triforium*) whose dimensions have been measured at 4.5 m high and 8 m wide.[20] The level of the cloister which over time has become noticeably higher than that of the basilica does not allow a visual appreciation of this aspect. Since the arched entryway was opened by breaking down the perimetral wall, we can deduce that it was built when the latter already existed. An analysis of the wall dates it to not before the reign of Sixtus III. The reconstructed church was therefore endowed with a prestigious passageway leading from and towards a space or complex of spaces which we can suppose had great liturgical importance. Figure 17 shows the reconstruction of the entire wall. The only possible hypothesis is that this was a baptistery. The presence of a baptistery complex is confirmed by the existence, on the same wall, of a small sized entryway that constituted the passage from the narthex or portico of the early Christian basilica towards a *secretarium* (fig. 18). All of this is in keeping with Sixtus III's pastoral policies to endow as many Roman parishes as possible with baptistery facilities to help spread Christianity throughout the urban area.[21]

Fig. 17.
Reconstruction of the internal South wall of the Paleo-Christian basilica Drawing by E. Roio.

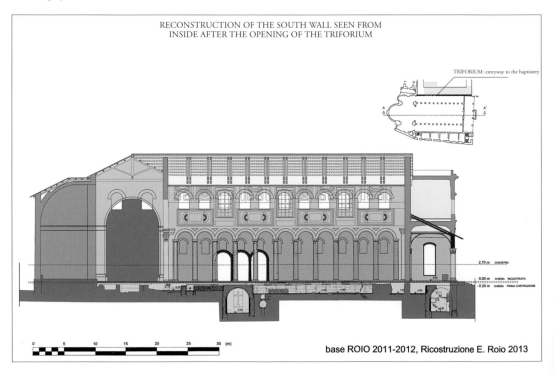

RECONSTRUCTION OF THE SOUTH WALL SEEN FROM INSIDE AFTER THE OPENING OF THE TRIFORIUM

TRIFORIUM: entryway to the baptistery

2.70 m. CHIOSTRO

0.00 m. CHIESA RICOSTRUITA
-0.20 m. CHIESA PRIMA COSTRUZIONE

0 5 10 15 20 25 30 (m)

base ROIO 2011-2012, Ricostruzione E. Roio 2013

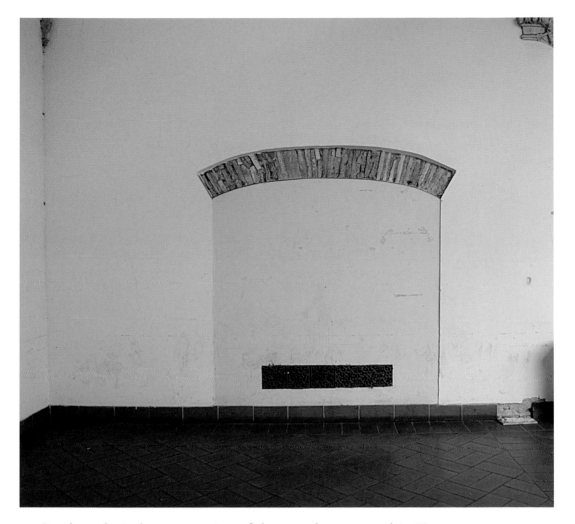

Our hypothetical reconstruction of the complex presented in Fig. 19 from two different angles (a and b) takes into account the important consideration that an adjoining ancient building[22] existed on the South side of the basilica that would not have allowed the baptismal complex to be built in that direction. Thus, it was necessary to arrange the rooms along the South side of the church. This arrangement also reflects the presence of the entryway into the *secretarium* at the narthex and of the triforium much further down, and moreover, it does not conflict with, but rather is complementary to the liturgical function of the ceremony.

Fig 18. Upper arch to the connecting room in the South wall of the Paleo-Christian narthex. Photograph by G. Bartolozzi Casti.

The *secretarium* was the room where the pope put on his sacred vestments on the occasions in which he took part. He must certainly have been present the day the church was dedicated (*in octava Apostolorum ad Vincula)* on 1 August according to the Gelasian and Gregorian sacramentaries.[23] The reconstructed image shows a series of aligned rooms: after the *secretarium,* the *lavacrum* where the catechumens

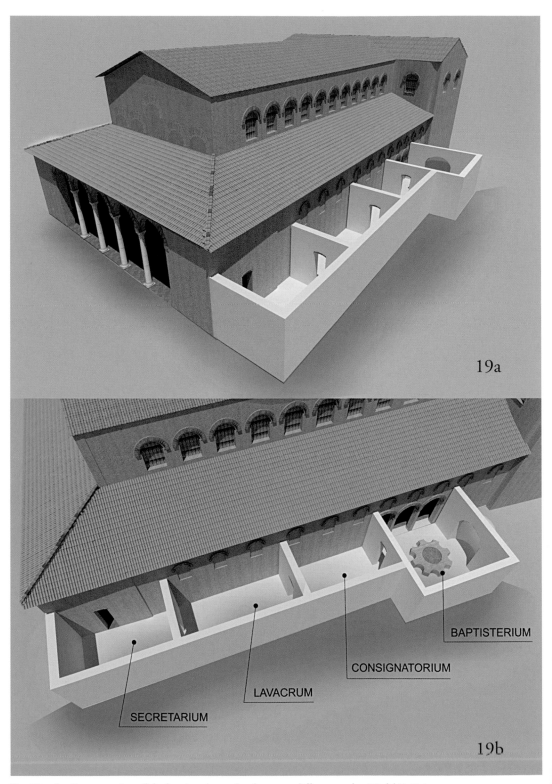

Fig 19 a, b. *Reconstruction of the baptismal complex from two different angles. Model E. Roio.*

about to be baptized donned the white robe (*vestis alba*), then the *consignatorium* for the *confirmatio* and finally the *baptisterium,* the largest space in the complex endowed with a baptismal font for immersion, usually octagonal in shape, with the monumental triple arched entryway leading into the basilica. The procession of the baptized, still clad in white, after receiving baptism left by the door of the *secretarium* and led by the deacons made their official entrance into the basilica through the main door where they received the eucharist. Ours was a titular baptistery and not a papal one like the Lateran and so the sacraments were administered by the presbyter.[24] However, on the solemn occasions when the pope was present, as in the abovementioned *octava Apostolorum,* he initiated (*incipit*) and then presided over the ceremony.[25] In order to obtain more information on the baptismal rooms, a thermography was performed.[26] This failed to indicate the presence of any other intervening rooms in the sequence of chambers that made up the baptismal complex whose shape has been accurately reproduced by using this advanced technique. Given the current situation with the monastery adjoining the basilica's South side, which is today home to the Faculty of Engineering, the baptismal font may never be found.

V. The Cult of the Chains and the Name of the Church

The basilica derives its current name from the chains that according to a very ancient legend are said to have bound Saint Peter during his Roman imprisonment and they are still preserved in the church as sacred relics, but not in their original location and housing (see following chapter).

How the Petrine chains arrived in the church is not known. Certainly they must have been present in the sanctuary from the very earliest times and we have the testimony of this from one of the inscriptions copied by pilgrims mentioned at the beginning of chapter III[27]. The existence of the chains in the church has been associated with the nearby basilica of the Urban Prefecture, where Christians were tried and martyred. But Peter was martyred between AD 64 and 67 so the question remains where the chains were kept for some four centuries. Nothing is known about their whereabouts during that time.

Later writers took up the topic, and it became the subject of romance and legend. In the *Passio Alexandri, Eventii et Theoduli* by an unknown author, there appears the figure of Balbina who is said to have rediscovered the chains that had bound Peter in Jerusalem. According to Paul the Deacon (or perhaps Alcuin), Eudoxia, the mother of Theodosius II found the chains in Jerusalem and donated them to the pope, and they subsequently united with the Roman chains. Bypassing the other authors, we find in Siegbert de Gembloux that the chains had become three. Finally Cesare Baronio assembled all of the accounts, but prudently introduces each of the stories with the qualification "it is said".[28]

As we mentioned above the church's first name was *Basilica Apostolorum*. However, as of the end of the 5th century, the second name referring to Peter's chains is often found in the documents, tacked on to the first as sort of specification with expressions like *basilica/ titulus Apostolorum (quae vocatur) ad vincula Sancti Petri*. Finally, the designation referring to the Chains was made official when Hildebrand of Soana was elected pope in our church in 1073 with the name of Gregory VII.

The cult of Saint Peter's chains had spread from earliest antiquity. Sovereigns or high prelates asked for tiny pieces or shavings from the chains as sacred relics, including the future emperor Justinian in 519. Many churches were built dedicated to the chains of Saint Peter. Some of the best known in Italy were: Spoleto; Pisa; an ecclesiastical and reception complex near Ravenna also called San Pietro in Vincoli; Pavia. In other provinces of the empire: Numidia, Provence, Hungary.[29]

V. 1. *The Location of the Chains in the Basilica*

We have no definite information as to how the chains were housed within the church in ancient times. Nevertheless, since they were relics we can be fairly certain that they were preserved inside the altar in keeping with early Christian custom. This is confirmed by the position of the mosaic inscription mentioned above *Inlesas olim* placed in the apse (*sub tribuna*) which referred to the altar standing in front.[30]

We are justified in supposing that the chains were removed and re-located when cardinal Nicola Cusano had a special altar built in the left extremity of the transept[31] (see chapter IX).

In 1650 they were placed in the sacristy in a precious reliquary (see chapter XV).

With the construction of the crypt or *confessio* ordered by Pius IX based on a project by Virginio Vespignani (illustrated in the following chapter) the Holy Chains found the most appropriate location imaginable and where we can still admire and venerate them today.

VI. The *Confessio* or Crypt

In 1876-1877, during the papacy of Pius IX, construction was proceeding on a *confessio* or crypt which even after the subsequent alterations it underwent, for reasons we shall see, became a nineteenth century version of the early Christian semi-anular crypt with a double staircase in front (figs. 20 and 21). Of these crypts, the first splendid example was built when Gregory the Great (590-604) systematized the tomb of the apostle Peter in the Constantinian basilica that was dedicated to him. Crypts of this sort span a period of time running from the papacy of Gregory the Great to the 10th century. They were particularly popular in the Carolingian period when the bodies of saints were being removed from the catacombs to churches within the city walls.

The design and construction of the crypt was entrusted to Virginio Vespignani, the architect who usually executed Pius IX's works. The decision was taken to open an excavated space 5 m long and 6.7 m wide. No canopy was built, the room described is therefore visible from the central nave and surrounded by a balustrade of polychrome marble inlay that resembles Cosmatesque work, as do the floor and internal walls of the crypt. The balustrade has two symmetrical entrance doors leading to the descending staircase. According to the project, the rear portion of the main altar constitutes the back wall of the *confessio*. The

Fig. 20. *Virginio Vespignani, the Confessio with the Holy Chains. Photograph by G. Bartolozzi Casti.*

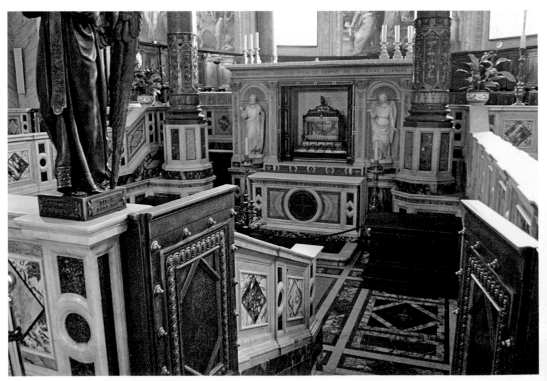

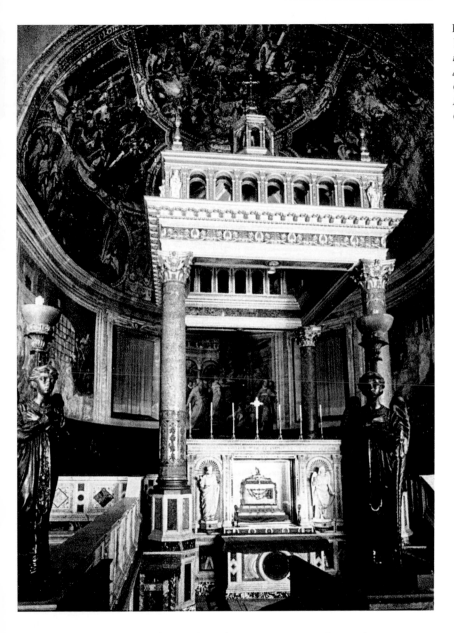

Fig. 21. *Virginio Vespignani, Altar of the Holy Chains and above them the Ciborium. Photograph by G. Bartolozzi Casti.*

chains which had been housed in the sacristy in a silver reliquary were now placed in a precious bronze casket (chapter below VI, 2) that was set into the centre of the main altar underneath a large neoclassical ciborium with two upper levels.

VI. 1. *The Sarcophagus of the Maccabees*

The first stone, taken from a catacomb, was laid on August 8, 1876. One can quite understand the pope's fondness for the place where fifty years before he had been consecrated Archbishop of Spoleto in May 1827. Quite unexpectedly the work was enriched by other precious

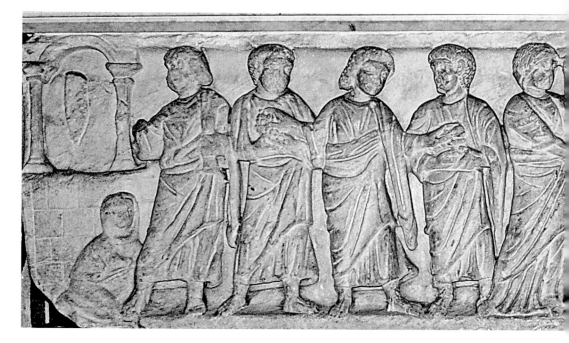

Fig. 22, detail. *Thrice crowing rooster.*

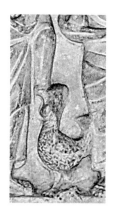

relics that were respectfully relocated and honoured. During the course of the excavations on September 2, 1876 an ornate sarcophagus was discovered with reliefs depicting scenes of Christian subject matter (fig. 22). It was lying lengthwise along the church's central axis underneath the base of the altar with one end touching the foot of the altar table. The sarcophagus proved to be the reliquary of the remains of the seven Maccabees and their mother.

The find led to a change in plans. Between the crypt and the sides of the altar of the chains two stairways were opened at angles to each other, each with fourteen steps leading to a second smaller crypt in the back that had a rectangular shape. The sarcophagus was placed lengthwise, towards the apse (east) and on September 3 it was opened in the presence of the ecclesiastical authorities and representatives of the Pontificia Commissione di Archeologia Sacra. Inside it was divided into seven compartments, each of which contained ashes and fragments of bone. Two inscriptions were also found engraved on lead plates whose textual content was very similar, one inside the sarcophagus and the other in the ground not far from it. Their texts leave no room for doubt that the relics (real or presumed) belonged to the seven Maccabee brothers.

The Maccabees were brave Old Testament martyrs venerated by the Christians and held by them to be the precursors of their own co-faithful who were martyred bearing witness to Christ and so included in the martyrologies and celebrated in Christian feasts. The names of the Maccabee brothers have not come down to us from the Bible. The events occurred towards the middle of the 2nd century BC when king

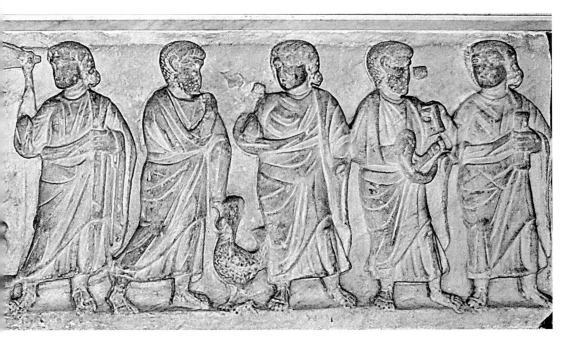

Antiochus Epiphanes wanted to force them to eat pork which is pro-hibited by the law. Because of their firm refusal to do so they suffered martyrdom by mutilation and fire. One after another they were mar-tyred, the last being their mother who had not ceased inspiring them with courage.[32]

As regards the person responsible for bringing the relics to Rome, an inscription transcribed on an *incunabulum* housed in the Biblioteca Casanatense identifies him as Pelagius I (556-561). The verse has also been reported by Martinelli (*Roma ex aethnica sacra*).[33]

This sarcophagus is important not just because of the archaeologi-cal events surrounding its discovery and related historical, hagiograph-ical and liturgical questions. Rather, it possesses important formal mer-its, especially in its composition and the fact that it can be dated with certainty to the end of the 4th century.

It is made out of white Parian marble with a slight bluish-grey tinge and decorated only in the front portion. The original lid has not sur-vived. When the reliquary was introduced the lid was replaced by a slab from a different place and this is now on the wall in front of the votive chapel. Where it was originally destined to go and its previous location are unknown. It is what is called a continuous-frieze sarcophagus because the scenes are depicted without any representation of architecture acting as a partition between them. The heads appear to be a little spheroid as a result of having been buried and the events they had been subject to. Five episodes are shown. We shall look at them starting from the left.

The *Raising of Lazarus* is made up of two figures with Christ the miracle-worker, symbol of salvation and the final resurrection of the

Fig. 22, detail. *The Raising of Lazarus.*

Fig. 23. *Sarcophagus of the Maccabees, Scene of the multiplication of the loaves and fish. Photograph by G. Bartolozzi Casti.*

dead. The sepulchre acts as architectural background and does not terminate as usual, in a tympanum at the top, but in a sort of colonnaded portico underneath which may be seen the figure of Lazarus. Missing is his sister who is usually depicted. Lazarus is bound up in strips of cloth that do not cover his face as in the pictorial scenes.

The *Multiplication of the Loaves* (fig. 23) alludes to the saving power of the eucharist and is perhaps the best scene, the only one made up of three personages. The composition is tightly arranged with a hieratic Christ at the centre whose arms are stretched out as he holds out the loaves and fish, fruit of the miracle. The attitude is almost that of a figure in prayer and it indissolubly unites his divine nature with the humanity of the figures on the sides who need food, symbol of the entire human race.

The *Samaritan Woman at the Well* where the water signifies purification and life in Christ with an allusion to baptism. The upper structure of the well depicts an isolated arch in the centre according to a motif from pagan sarcophagi. The composition vaguely alludes to and prefigures later examples known as "city gate" sarcophagi which developed on the motif of arches and architraves used to divide up the scenes, but which very often had a central arched component or an architrave in greater relief or placed a little higher up. The tendency is confirmed by the vertical lines and the clarity of the entire composition besides recalling the columns on the left in the scene of Lazarus.

The final two scenes have to do with Peter. The prophecy of the *triple denial* is immediately recognizable by the presence of the rooster. Finally, Christ handing over the keys to Peter or *Traditio clavium* – in other examples instead of keys, Christ is handing over a scroll of the law: *Traditio legis*. This final scene is composed in a binary arrangement, which is a sign that it is earlier than the ternary composition (Christ-Peter-Paul). Very likely it was the presence of the two last scenes of Petrine inspiration that led to the choice of the sarcophagus as a reliquary in a church named after the Apostle.

The faces and the heads have simplified features and have been worn away by the action of the earth in which they were buried, but the artist reveals a fine sense of composition. The base of Lazarus' tomb on which the columns rest, the outstretched arms of Christ in the multiplication of the loaves and the upper boundary of the Samaritan woman's well form a continuity that generates a horizontal linear motif softening but not disturbing the clean vertical lines mentioned above, which is a main feature

of the entire work. The work may be dated, also from the hems of the garments depicted, to the reign of Theodosius, perhaps not the later part.
 [G.B.C.]

VI. 2. *The Reliquary of the Holy Chains*

We know that the Holy Chains were previously kept in the "tribuna" (which is perhaps to be identified with the main altar).[34] From 1465 they had their own altar built by Cardinal Nicola Cusano (see chapter IX). In 1650 the abbot Giovanni Alfonso Puccinelli donated a silver case to house them in the sacristy. Housed in a chest inside a space made of square panels of prized marble inserted into the walls and closed off by a wrought iron grating, the chains remained hidden from the faithful during the course of the year.

To make the relic more visible and encourage its cult among the many devotees, in July 1856 the cardinal-priest at the time, Nicola Parracciani Clarelli gave to the basilica a new reliquary casket, which is the current one (fig. 24). The design is by Andrea Busiri. The square-

Fig. 24. *Andrea Busiri Vici, Reliquary of the Holy Chains. Photograph by G. Bartolozzi Casti.*

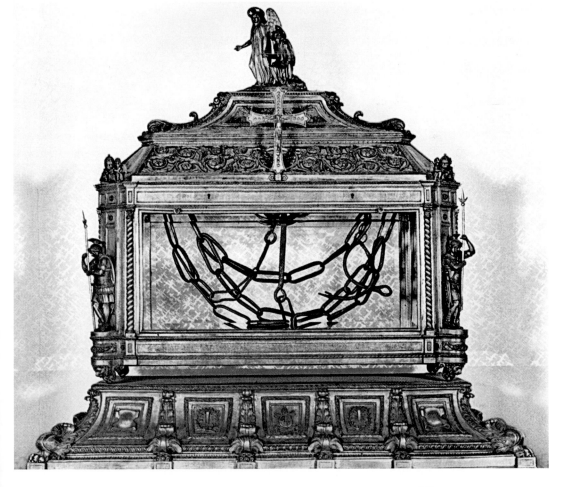

shaped casket is made of crystal with supports and decorations in gilt metal: it rests on a base made up of alternating reliefs showing coats of arms (those of Pius IX, the cardinal-priest and others) repeated on the cover which has fretwork and crystal ornamentations. Four sleeping guards lean against the bevelled corners (currently the two front ones are missing), and the group with Saint Peter and the angel stand on the roof shaped cover. The figures depicted refer to the story in the *Acts of the Apostles* that tells of Peter's liberation from prison in Jerusalem.[35] The inscription in the frame of the reliquary's resting place refers to this: *the angel sent by the Lord breaks the chains, frees the apostle and, passing amid the sleeping guards, leads him out of prison.*

VI. 3. *The Reliquary Doors*

Fig. 25. *Doors of the Reliquary of the Holy Chains. Photo by Mallio Falcioni.*

There are two small doors (fig. 25) which use a sliding mechanism to close off the space where the Holy Chains are kept. They were mentioned by Albertini[36] among the many works commissioned by

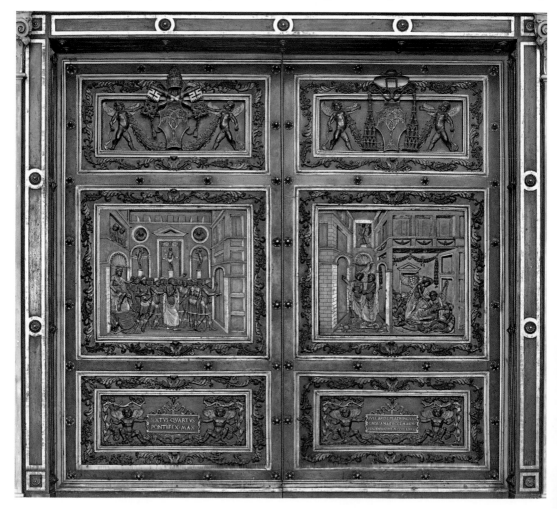

Julius II in the churches of Rome and come from the above-mentioned altar of the Holy Chains that no longer exists (see chapter IX). They are made of bronze and gilt metal: the decoration is divided into three square framed sections and placed symmetrically in two panels decorated by elements alluding to the coat of arms of the Della Rovere family (oak tree). The papal arms of Sixtus IV (Francesco della Rovere) and the cardinal's arms of his nephew, Giuliano della Rovere, later Julius II (in the upper squares), and the scroll ornament bearing inscriptions related to the reigning pope and the cardinal – the basilica's titular cardinal from 1471 – (at the bottom), are testimony to the devotion of these prestigious patrons. The date *MCCCCLXXVII* situates this elegant work during an important period of architectural patronage undertaken by the della Roveres in the basilica between 1471 and 1479.

In the central part we see *The Condemnation and Arrest of Peter* on one side and on the other *The Angel Freeing Peter and Leading him out of Prison*. The representation of the scenes tells the story from an architectural context of the 15th century with lacunar ceilings, strongly foreshortened lateral apertures and its portrayal has an antiquarian taste: statues, busts in decorated niches, figures wrapped in stiffened drapery. Soldiers and armour were inspired by commemorative reliefs of Roman monuments.

An old tradition attributes the work to Antonio del Pollaiolo[37] who lies buried in the basilica along with his brother Piero. This claim – without any critical-historical evidence – may derive from the fact that the cardinal Giuliano commissioned Pollaiolo to execute the tomb for Sixtus IV (Grotte Vaticane) in 1484. Scholars have sought confirmation in the milieus of goldsmiths, engravers and sculptors of the time (Cristoforo Foppa "il Caradosso"; Cristoforo di Geremia).[38] The artist belonged to an artistic milieu that had formed around masters coming from Tuscany, Lombardy or from the South of Italy, such as Paolo Romano, Mino da Fiesole, Andrea Bregno who were active in the papal court during the second half of the 15th century and developed new forms that drew on a direct experience of ancient monuments, sculptures and commemorative reliefs.[39]

VII. The Mosaic Icon of St. Sebastian

Today we can admire the icon of St. Sebastian in the third altar on the left (fig. 26) decorated by multicolour marble inlays. Above the mosaic there is a *tondo*, or circular painting, of the Virgin and Child. Both images are framed on the sides by two *portasanta* marble columns surmounted by Corinthian capitals.

The cult of St. Sebastian was present in Rome from earliest times. On the Appian Way there are catacombs and a Constantinian basilica that since the 12th-13th centuries both bear the name of St. Sebastian. After being moved to the Vatican (Gregory IV, 827-844), the martyr's remains were brought back to their original burial site, which had already been transformed into a crypt and endowed with a Cosmatesque altar by Honorius III in 1218. St. Sebastian was venerated as a miracle worker and his cult in our church is associated with the plague of 680 which raged in Rome at the time of Pope Agatho[40] and in Pavia[41] when Damian was bishop of that town and Cunipert the Christian king of the Lombards. Centuries later, in 1476, there was an outbreak of plague in Rome and a concomitant revival of the cult of St. Sebastian, which had never been forgotten. Both epidemics were averted through the saint's intercession.

I shall complete the description of St. Sebastian by adding that he was unquestionably a historical martyr. His feast day is celebrated on January 20 in the oldest Christian calendar, the *Depositio martyrum,* which uses the primitive expression *in Catacumbas* to indicate his deposition. He is mentioned by St. Ambrose in his commentary to Psalm 118. Ambrose thought that Sebastian originally came from Milan. Be that as it may, Sebastian is included in all the martyrologies and sacramentaries, even if we know little about the circumstances of his martyrdom.[42] A legendary narrative of his martyrdom (*passio*) is thought to have been composed in the time of Sixtus III (432-440). The *passio* relates, although we do not know on what basis, that Sebastian had reached a high military rank in the Praetorian Guard and was executed by being shot by arrows.

The image that represents him may be ranked as a true votive icon and not just any sacred image. The panel is rectangular in shape and measures approximately 155 x 75cm. Its original location was on the interior wall of the façade on the left for those entering, as we shall see below.

Recently the image has been restored by careful cleaning done by the Istituto Centrale del Restauro di Roma (Giuseppe Basile).

The iconographic study that follows was made possible by a digital reflectometry analysis carried out by the Dipartimento di Fisica Tecnica dell'Università di Roma "La Sapienza" (Prof. Pierluigi Testa, Engineer Ivan Roselli).[43] This rather technologically advanced method has made it possible to identify both details that have never before been seen and those areas where restoration work had previously been performed.

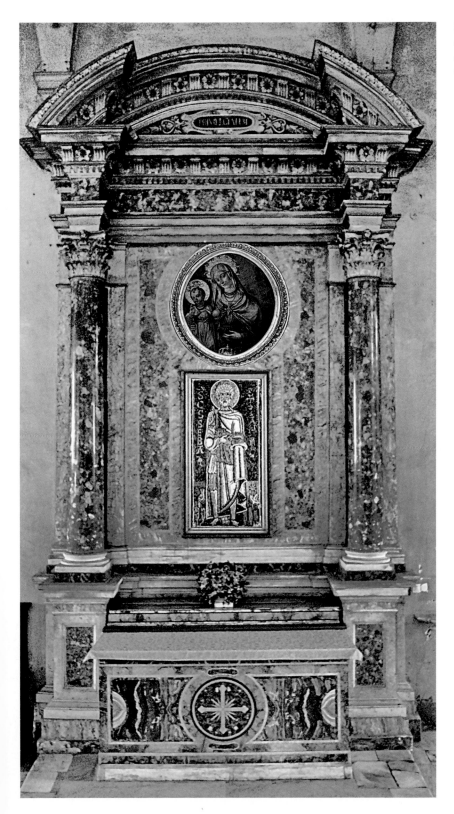

Fig. 26. *Altar of*
St. Sebastian.
Photograph by
G. Bartolozzi Casti.

VII. 1. *Critical Analysis*

Of extremely high quality, this work shows the haloed martyr standing erect, facing us in the military garb of the time (fig. 27); he is clad in a close fitting tunic bound at the waist; typical soldier's *clamys* with a clasp on his right shoulder; a purple *tabula*; in his right hand he holds the jewelled crown of the martyr; his feet rest in an area that is typical of the paradisiacal garden; behind him the line of the horizon at the height of his knees acts as a border between the paradisiacal garden and an intensely blue sky against which the figure of the saint stands out. The round object at his feet bearing a cross and, about which much has been written, was in reality added in restoration, and is a decorative four-petalled rosette of the kind that may be found in other locations (vault of the oratory of Innocent III, 1198-1216, in the catacomb of Saint Sebastian). This latter detail may help to date the early restoration. The name of the saint which leaves no doubt as to the identity is written vertically in golden letters on both sides of the figure. The two inscribed sections frame and serve to highlight the figure's upper body, the one on the right is an old restoration.

The dress is similar in every respect to the garb of the Dalmatian soldier saints depicted in the mosaics of the oratory of St. Venantius at the Lateran baptistery[44], which work was created under John IV (640-642) roughly forty years before the piece under consideration. However, the stylistic representation of those martyrs is completely different and is clearly influenced by Byzantine mosaic art with its emphasis upon certain traits such as elongated bodies that appear to have almost no physical substance underneath their vestments. It is possible that they were done by Eastern artists commissioned by the pope. Saint Sebastian, on the other hand, in spite of some vague chronologically inevitable resemblances with several Byzantine cultural conventions such as the extensive use of golden tesseras, the frontal posture of the figure and its rigidity, is heir to an entirely different tradition. The head with its curly hair suggests the artist was familiar with certain heads from the classical Roman statues and sarcophagi, particularly the age of the Antonine emperors in which the particular hair style was sculpted by using a drill: examples are on Trajan's column and the sarcophagus of the Maccabees in our own church (figs. 22 and 23).[45] Especially significant is the comparison with the upper part of the equestrian statue of Marcus Aurelius (figs. 28 a and b). Here was born a style that would be repeated later in paintings and mosaics and passed on by the artists of the Roman school, for example in the depiction of angels, particularly the angel on the right of the icon of the Virgin *Theotókos* in Santa Maria in Trastevere done in the last decades of the sixth century; right up to certain figures in fresco and mosaic of the *Sancta Sanctorum* in the mid or towards the end of the 13th century.

As regards the use of colour it is rather difficult to find in that particular period a mosaic that has the same vivid colours sometimes

Fig. 27, detail.
The Crown of Martyrdom.

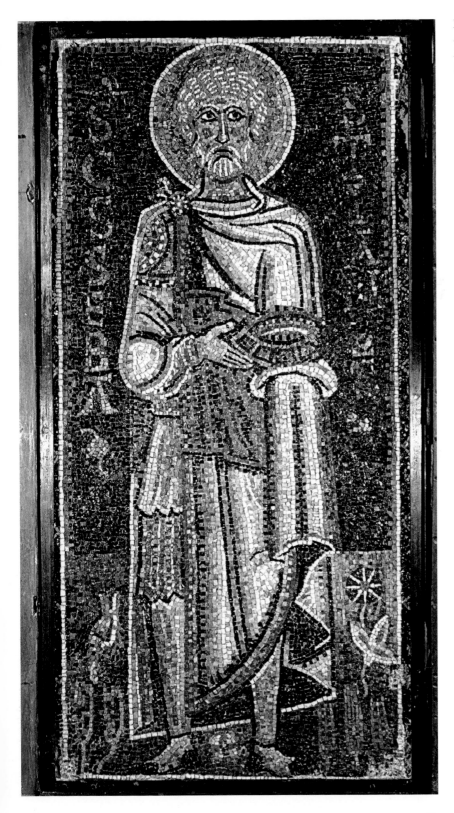

Fig. 27. *Mosaic Icon of St. Sebastian. Istituto Centrale per il Restauro.*

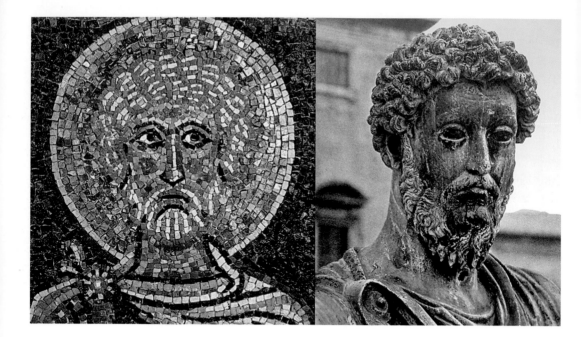

Fig. 28. a, b.
Comparison of the
heads of St Sebastian
and Marcus
Aurelius.

concentrated in short strings of tesseras, particularly red-vermilion, that may even be found on the face resembling impressionistic touches of colour (fig. 28a).

The saint is represented as being mature or elderly. It has been remarked in this regard that if he reached the rank of commander in the Praetorian Guard, as the *passio* tells us, then he could not be depicted as too young, as later iconography did from the 13th century. In the 16th-17th century (Guido Reni) Sebastian was even portrayed as a young ephebe. The intense, severe expression of the bearded face is inspired by a familiar facial type. It reminds us of the face of Peter and before him, that of Moses, in a Christian iconography that establishes a continuous tradition running though the figurative arts: the people of Israel, the people of Christ and the people of Rome when decimated by the plague stand in need of a trustworthy, miracle-working guide. Some observers have remarked that our figure is not in proportion, with his short legs and large head (Kitzinger). This imprudent claim might make sense if we compare it to the elongated, incorporeal figures of Byzantine art. Actually, the artist made a realistic portrayal of the physique of the average Roman man of the period, that is, an officer of the militia of the Roman Duchy (*exercitus Romanae civitatis*), formed in the second half of the 7th century and under the control of the Exarch of Ravenna.[46] We are justified in concluding that the artist was the head of a school and well integrated in the Roman milieu, conceivably by birth as well as culture. Indeed, some parts of the saint's military dress resemble the lamellar armour that has been found in the *Crypta Balbi.*[47]

It has been claimed that the entire left portion of the mosaic underwent restoration. To be precise, it has been said that the flower sprouting from the ground was inexpertly restored by someone incapable of the quality of the flower on the right.[48] A careful examination of the icon through an analysis of its materials has established beyond any doubt that what was previously assumed to be a poorly executed flower on the left is in reality a dove, recognizable because of its beak and red feet; it is holding a grain from the ear of wheat below, symbol of the bread of the eucharist (fig. 29). It follows therefore that the bird, often shown in paradisiacal gardens was part of the artist's original project, which rules out any possibility of a later restoration. The inscription *scs sebalstianus* in gold tesserae is divided into two vertical sections on either side of the saint. The difference between them is noticeable and the portion on the right, as we said, is certainly a restoration as is shown by palaeographic analysis of the letters.

Fig. 29. *Mosaic Icon of St. Sebastian, detail of the dove. Photograph Ivan Roselli.*

The technological analyses performed on the basis of the critical, historical and artistic examination make it clear that it was not the left side, but the right side along the edge that was restored long ago at an unknown moment.[49]

VII. 2. *The Original Location of the Mosaic*

Numerous literary references from Carlo Sigonio (1520-1584) to Muratori (†1750) as well as drawings by Ciacconio (†1599) and Mellini (†1677) have enabled us to determine the previous position of the icon and the movement of the votive corner (I do not consider the expression altar to be appropriate) in which it was placed. It should be added that historians were responsible for generating confusion by merging into a single story the testimony of the *Liber Pontificalis*, which refers to Rome, and that of Paul the Deacon, who refers to Pavia. It was Muratori who finally sorted out the question.

The icon panel of Saint Sebastian was composed on the occasion of the terrible plague of 680 mentioned at the beginning of this chapter. It was placed at the centre of the internal wall of the façade between the left entrance door and the first pillar of the North colonnade. Sebastian roughly occupied the same place where today's window was later installed. There are no references to an earlier location.

VII. 3. *The Fresco on the Right*

While the plague of 1476 was raging or perhaps immediately after it stopped, this fresco was added to the internal side of the same pillar

as a thank-offering. In the floor plan in fig. 30 we can see the relative positions of today's altar and the votive corner. Let us examine the scenes that make up the painting (fig. 31). At the upper level, a high ranking personage is addressing a plea to the pope; on the sides, the images of Peter and Paul document that the ancient dedication of the church had not been forgotten.

In the central part we see the good angel and the bad angel mentioned by Paul the Deacon. A wicked being strikes blows with a pike against the houses where as many people die as the number of his blows. Below the dead lie in a jumbled mass as reported by the *Liber Pontificalis* and Paul the Deacon.

On the left from the centre downwards the propitiatory procession seeking refuge from the plague is led by a person of papal rank. We can see an image of the Blessed Virgin borne in honour by the procession.

The humanist and Roman historian Stefano Infessura maintains that both the papal figures represent Sixtus IV but we need only look at their facial features to see this is a mistake. The face of the figure in the upper portion is clean shaven and without any kind of characterization; the figure below in the procession has a beard, clearly portrayed and expressive. We can only conclude that these are two different moments in time depicting two different personages. Above is the plague

Fig. 30. Position of the altar of St. Sebastian and the mosaic compared to its original position. Drawing E.Roio.

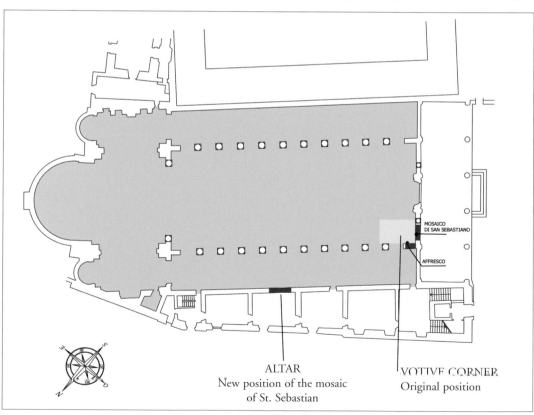

ALTAR
New position of the mosaic
of St. Sebastian

VOTIVE CORNER
Original position

MOSAICO
DI SAN SEBASTIANO

AFFRESCO

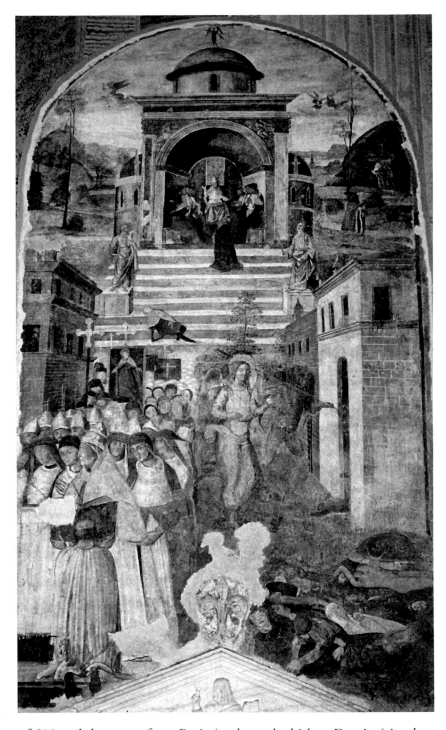

Fig. 31. *Fresco painted on the occasion of the plague of 1476. Roman school of the late 15th century. Photograph by G. Bartolozzi Casti.*

of 680 and the envoy from Pavia (perhaps the bishop Damian) implor-
ing pope Agatho, whose facial features the 15th century artist could not
have known, to give him a relic of Saint Sebastian. The propitiatory
procession below refers to the Roman plague of 1476 and the pope at

the head of it is Sixtus IV whose face the artist was quite familiar with. It is clear that the work combines both calamitous events from the end of the 7th and end of the 15th centuries. An image of the Virgin is carried by the procession in the lower section. It is again Infessura who identifies this as the icon of the *Salus populi Romani* found in Santa Maria Maggiore. In reality, the latter is considerably smaller and in it the Virgin is shown holding the Divine Son who is absent from the image in our fresco.

As regards the artist, we can say that it was a competent painter of the Roman school of the late 15th century. It has been suggested that the artist was a pupil of Antoniazzo Romano, if not the master himself.

Fig. 32 Unknown artist of the 15th century, Madonna and Child. *Photograph by G. Bartolozzi Casti.*

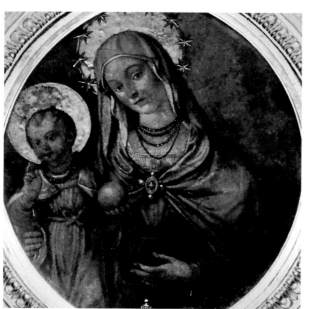

VII. 4. *Renewal of the Votive Complex*

In 1576, marking the centenary of the miracle of the cessation of the 1476 plague, Teseo Aldrovandi, Canon of San Salvatore in Bologna and Commendatore of Santo Spirito in Sassia ordered a composition with a painting of the Virgin and Child at its centre (fig. 32); to the right of the Virgin was the mosaic we have discussed and to its left another image of St. Sebastian pierced by four arrows (fig. 33) as related in the legendary *passio*. This latter work, which has disappeared, has survived in a reproduction — of unknown fidelity — by Ciacconio.[50] Ciacconio gives both reproductions: the mosaic icon and the other image with the arrows, both of which seem rather freely drawn. Under the image of the Virgin there is a commemorative plaque referring to events both in Rome and at Pavia. Fig. 34 shows a reconstruction of the votive corner.

VII. 5. *The New Altar*

Between 1681 and 1683 the votive complex described above, which could be considered a sanctuary within the sanctuary was dismantled by order of pope Innocent XI Odescalchi (1676-1689) so as to create the altar which we mentioned at the beginning of this chapter and which still exists today (fig. 26). The pope, in fact, urged on the work which was proceeding slowly.

With consummate skill the icon of St. Sebastian was pulled down from the wall and placed at the centre of the new altar above the

eucharistic table and the image of the Virgin was also taken down, recut as a *tondo* and placed above the icon of St. Sebastian. The marble plaque was placed to the lower right of the altar: at least one authority has claimed that it was rewritten (de Rossi). Only the fresco on the side of the pillar was left in place where we can still admire it, albeit damaged by the peak of the gable of the oddly situated tomb of the brothers Antonio and Piero del Pollaiolo (fig. 34 in the lower right).

[G.B.C.]

imago sᵗⁱ Sebastiani Martyris.
Ex pittura satis vetusta apud
s. petrū ad Vincula.

Fig. 33. *Unknown artist of the 16ᵗʰ century,* St. Sebastian pierced by arrows.

Fig. 34.
Reconstruction of the Votive Corner commissioned by Teseo Aldrovandi in 1576.
Design by E. Roio.

VIII. Major Interventions
from the 15ᵗʰ Century to the Present day

Nicola Cusano was titular cardinal of the basilica from 1448 until his death (August 11, 1464). In his last will he left two thousand ducats for the purpose of maintaining the church and promoting the cult of St. Peter.

To him we owe two important alterations, both from 1465: the restoration of the trussed wooden ceiling of the central nave – mentioned in an inscription carved on a beam divided into two parts with the date and the cardinal's coat of arms exposed over the colonnade under the new ceiling (fig.16) – and the construction of the altar of the Holy Chains in compliance with his wish to be buried in front of this ancient relic if he died south of Florence (see next chapter IX).

After the restoration work begun in the basilica by Francesco della Rovere (Sixtus IV) in 1471 and continued by his nephew Giuliano della Rovere (Julius II) with the renovations of the cross vaults over the lateral aisles, of the transept, of the portico with emblems of the della Rovere family and of the floors, another three cardinals of the same family and the titular cardinal of the basilica - Galeotto Franciotti della Rovere (1503-1508), Sisto Franciotti della Rovere (1508-1517) and Leonardo Grosso della Rovere (1517-1520) continued architectural and decorative work in the adjoining monastery and cardinal's palace[51]. The Canonici Regolari del San Salvatore dell'Ordine di Sant'Agostino were at the head of the basilica from 1489 on. The abbots-general of the Order, the *pro tempore* abbots of the basilica and the titular cardinal financed and left their names on memorials of symbolic value or works of great prestige. The image of the *Madonna and Child* (fig. 32) placed on an "altar" that had been commissioned by Teseo Aldrovandi (see chapter VII, 4) is a votive painting attributed to the school of Antoniazzo Romano (Antonio Aquili): it is product of a climate of renewed devotion to the Virgin promoted by Sixtus IV, and more in general, of the cult of her miraculous image which was particularly fervent at the time. In 1576 the "altar of the most glorious Virgin" was marked out for special favour by Gregory XIII with the celebration of a mass for the liberation from and remission of the sins of a soul in purgatory: this measure may be read in the inscription placed over the left side of the altar of St. Sebastian.[52]

In 1545 the della Rovere heirs finally managed to conclude the long drawn-out affair surrounding the tomb of Julius II, which was located here after the contracts of 1532 and 1542 (see chapter X).

Cardinal Antoine Perrenot de Granvelle, titular cardinal from 1570 to 1578 had the projection constructed over the portico, marking his own name on the lintel with the five windows and placing his emblem in the central one. Thus, that part of the original façade that

had paintings of the *Stories of Saint Peter* and the *Prophets* (Polidoro da Caravaggio and Maturino) came to be hidden. The frescoes that adorn the walls and calotte of the basilica's apse date to 1577 and were commissioned by the abbot general Raffaele Campioni from the Florentine Jacopo Coppi (1523-1591) as may be read in the inscription beneath the two niches with the image of the Saviour.

The basilica and its monuments were described in some detail in an account of the Apostolic Visit of February 2, 1628.[53] The lateral aisles were without altars: except for the tombs in the right aisle of the cardinals Girolamo Agucchi (†1605), Lanfranco Margotti (†1611) and Girolamo della Rovere (†1599) and two altars on the internal walls of the façade dedicated to St. Augustine (see chapter XII, 1) and St. Sebastian (see chapter VII, 2) on the right and left sides of the main entrance respectively. The chapel in the left transept named "della Pietà" or "SS.mo Sacramento" was decorated with paintings that have since disappeared. Two memorial plaques placed on the walls by the abbot general Tommaso Menzio in 1642 commemorated cardinal Antonio Barberini (1637-1642), who had commissioned its decoration, and Bernardino Spada (1642-1646), who had granted favours to the basilica. Moreover, by seeing to the restoration of the text of an ancient inscription in the altar of St. Sebastian, the abbot Menzio had underlined the importance of that place of worship.[54] In the garden of the cloister, another inscription by Menzio (1647) mentioned the fountain that had been donated by cardinal Antonio Barberini. In 1647 he set up yet another one to mark the occasion of his personal contribution to the construction of the "libraria", of a tower and of vaulted dwelling spaces. It was subsequently removed during the renovation of 1765.[55]

An altar in coloured marbles from 1631 adorned the tribune. It was commissioned by abbot Paolo Maffioli and bore an inscription indicating the relics of the Maccabees and the Holy chains. It could be seen right until the nineteenth century intervention by architect Virginio Vespignani (see chapter VI).

In 1674 abbot Alessandro Maria Salardi asked the Sacra Congregazione della Visita Apostolica for permission to move the altars of St. Sebastian and St. Augustine from the back of the church to the lateral aisles which had no altars. The request was aimed at increasing the stateliness of worship. His request was granted and the two altars were built between 1681 and 1682 (see the chapters on this).

In 1705 with a financial contribution by prince Giovanni Battista Pamphili and the abbot Alessando Cremona, from a design by Francesco Fontana, Cusano's wooden roof was hidden by a coffered, wattled ceiling. The contemporary painting in the centre is the first Roman work by Giovanni Battista Parodi which portrays the *Miracle of the Chains* (see following chapter XIII.2). On this same occasion other conservation work was carried out on the ceiling of the transept

of the lateral aisles and the structures of the tribune. In 1765 through the good offices of cardinal-priest Antonio Andrea Galli a new floor with bricks interposed with marble now covered the entire floor of the church, a job which also involved redoing the bases of the columns and pillars. The last great event (1876-1877) was the construction of the new high altar promoted by the Archconfraternity of the Holy Chains and executed following a drawing by Virginio Vespignani (see chapter VI). The most recent interventions include archaeological investigation in the wake of restoration of the floor (see chapters II and III) and the restoration and reinforcement with metal structures of the ancient trussed roof (1989-1992) which had been hidden by Fontana's 18th-century ceiling.

IX. The 15th-Century Altar of the Holy Chains

The altar[56] which no longer survives was located in the niche, still visible today, underneath the organ. A few fragments from the complex remain which were arranged in the early 18th century in the initial section of the left aisle along with a 17th century description by Benedetto Mellini[57]. The altar was made up of two reliefs supported by two columns in porphyry: one showing *The Story of the Imprisonment of St. Peter* (now lost); the other visible today, depicts the *Cardinal Cusano* against a dark background, enclosed by two elegant candelabra and illuminated by gilt sections. The figure of the cardinal is kneeling in front of *St. Peter Enthroned* whose hand points to the chains being held by the *Angel* kneeling on his other side. Beneath this group was the *tabula ansata* (today located above the relief) with the inscription indicating who was buried in the floor in front of the altar underneath the slab (today on one side of the relief) with the traced image of the prelate on it. Further back was the housing for the chains which in 1477 were closed behind the bronze doors. The statues of *St.*

Fig. 35. *Andrea Bregno,* Cardinal Nicola Cusano kneeling in front of St. Peter. *Photograph by G. Bartolozzi Casti.*

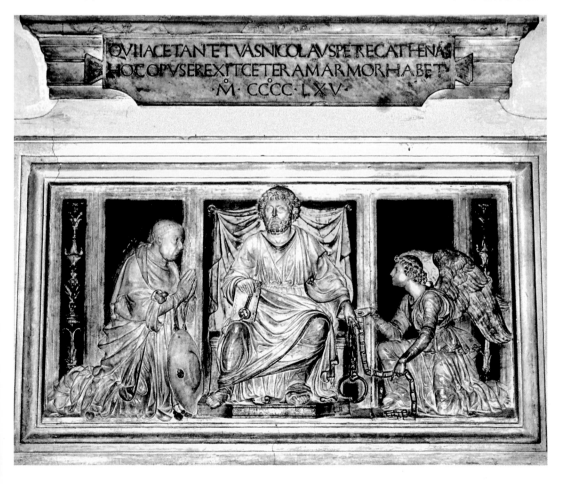

Andrew and St. Sebastian (now lost) flanked the two porphyry columns: the decorations must have included the cardinal's emblem of which only the shield with the cardinal's arms remains.[58]

We have reports that as early as the first decades of the 17th century the Holy Chains were exposed "under the High Altar" and that as of 1650 the relic was kept in the Sacristy in a silver reliquary. Thus, it appears that slowly the altar lost its original function and became the exposition place for the Holy Sacrament.

The relief is almost unanimously considered to be one of the first of the Roman works of Andrea Bregno (1418-1503): usually dated to 1464/1465, it would have been created just before the tomb of cardinal Louis d'Albret (†1465) in the church of Aracoeli. In the portrayal of Peter and in the bundled folds of Cusano's garments we can see a personal interpretation of ancient sculpture, just as the design of the candelabra shows the emergence of decorative features[59] that Bregno would develop on in his later works.

X. The Tomb of Julius II

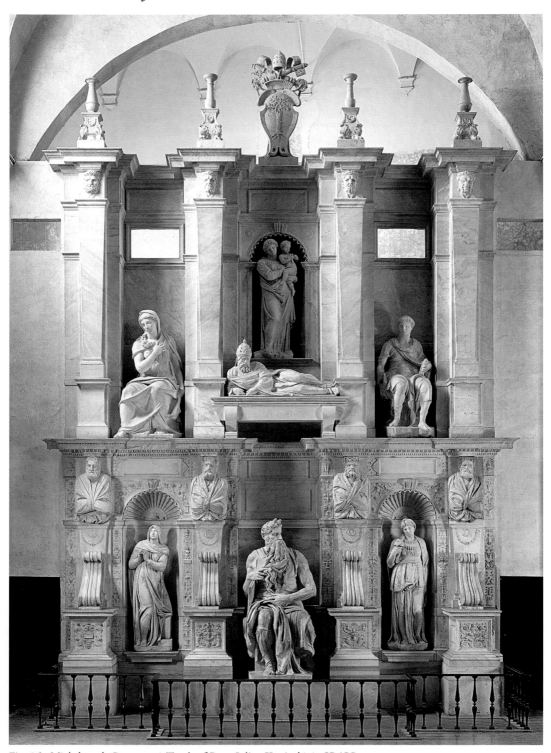

Fig. 36. *Michelangelo Buonarroti*, Tomb of Pope Julius II. *Archivio SBAPR.*

X. 1. *The Story behind the Monument*

The story behind the monument begins in 1505. In that year Julius II (Giuliano dela Rovere), who had become pope in 1503, summoned Michelangelo to design his funeral monument, which was to be located in Saint Peter's in the Vatican. We have no documentary record of this first agreement: certainly there were "many drawings". The biographers Vasari and Condivi describe the monument and critics have come up with many hypothetical reconstructions: an isolated tomb, with an interior oval cell, richly adorned with statues and bronze reliefs; the monument rose up in tiers recalling the design of ancient mausoleums.[60] This design was never executed because of the pope's wavering interest. After Michelangelo's flight to Florence and the reconciliation with his patron in Bologna (where he was working on a bronze statue of the pope), Julius II commissioned him to decorate the ceiling of the Sistine Chapel (1508-1512). The pope died on February 11, 1513. The executors of his will, cardinals Leonardo Grosso della Rovere and Lorenzo Pucci drew up a second contract with Michelangelo on May 6, 1513. Two drawings – one in Berlin (Kupfer-stichkabinett) and the other in Florence (Uffizi Gabinetto dei Disegni e delle Stampe) – illustrate the complex iconography: set against the wall the monument had three sides and presented *Victories* flanked by *Prigioni* ("*Slaves*") at the base and six large seated figures at the corners of the upper level; the figure of the pope on a bier held by angels is below a *Virgin and Child* placed in an oblong "cappellata" with other large figures on the sides.

Fig. 36, detail. *Arms of Pope Julius II.*

This design never came to fruition and there followed the signing of a third contract with the executors dated July 8, 1516. Now smaller and with fewer statues, the monument is placed against the wall with two lateral adjuncts, two niches on the front and one niche on either side with statues. On the upper level topped by a gabled cornice the figures of the Sybil and Prophets are arranged within enclosed spaces right over the lower niches; at the centre there was the "trebunetta" with the *Virgin and Child* above the two figures holding up the deceased pope. During the period between the two contracts, Michelangelo was working on the two *Slaves* (today in the Louvre Museum) and *Moses*. This project, too, was never realized.

Except for the brief papacy of Adrian VI (1522-23), the third decade of the century was not favourable to the della Rovere family. Having been deprived of their duchy by Leo X – later restored by Adrian VI- and frustrated in their plans for a tomb by the commissions imposed on Michelangelo in Florence first by Leo X and then by Giuliano de' Medici (Clement VII 1523-1534), the della Rovere asked for their money back with interest. Forced to comply with the requests of the pope, Michelangelo wished to be freed from his commitment to the della Rovere heirs. He was willing to return the money to the Duke of Urbino, resign the commission and hand over his plans to other masters.

In 1525-1526 a "shorter" solution was envisaged of a tomb with walls "like those of Pius", that is the 15th-century tombs of Pius II and Pius III,

today in the Church of Sant'Andrea della Valle. This project, whose plans have been identified, was not to the liking of Francesco Maria della Rovere.[61] It was only after lengthy negotiations between representatives of the Duke of Urbino and Michelangelo that a new contract was drawn up on April, 29, 1532 calling for yet another design with six statues "already begun…by his hand" (but not identified), the permission to contract out to other masters and the choice of a new location, since the original placement in Saint Peter's in the Vatican was no longer an option. Among the churches in Rome connected to the della Rovere family, such as Santa Maria del Popolo, San Pietro in Vincoli seemed the most suitable. Michelangelo had in mind the North wall of the transept where the altar of the Chains was situated (see Chapter IX) which, however, would have to be moved. This did not happen and the monument was placed up against the wall of the right transept bordering on the space of the antesacristy: it rises for the entire height of its pillars and penetrates into the space reserved for the "choir of the Frati" which Michelangelo connected to the basilica by opening a lunette in the relieving arch. Work which began almost immediately (1533-34) was interrupted. Pope Paul III (Alessandro Farnese) commissioned Michelangelo to paint *The Last Judgment* (Sistine Chapel 1536-1541). The state of progress of the work is shown in a drawing by Aristotele da Sangallo: the monument had been erected to the first level by Antonio da Pontassieve, and as may be seen in a drawing by an unknown artist and a rereading of the sources, the figure of the pope lying on the coffin was already in place.[62] The tomb as we see it today is the product of a contract of August 20, 1542 with the agents of Guidobaldo della Rovere. In addition to *Moses*, Michelangelo was required to provide five statues that had already been started: *The Madonna with the Child*, *The Sybil*, *The Prophet*, *The Active Life* and *The Contemplative Life*: the latter two replaced the two *Slaves* that had been conceived to go with another design of the project. The job of finishing all of these was subcontracted on August 21 to Rafaello da Montelupo, to Francesco d'Amadore (l'Urbino) and Giovanni de' Marchese was given the work of framing and decoration. The statues of *Active Life* and *Contemplative Life* were later finished by Michelangelo as may be seen in the agreement of August 23. Other helpers contributed: Sandro Scherano da Settignano sketched the statue of the *Virgin*; Battista di Donato Benti made the coat of arms of Julius II; Iacopo del Duca was paid ten scudi "for four end heads" (upper level). The monument was completed in 1545.

X. 2. *The Monument*

The tomb conveys the triumphant idea of the earlier projects and became a wall tomb with a single façade that was much inspired by the theme of salvation (fig.36). On the lower level four pillars terminate in *herms*. Their heads support overturned mantelpieces placed on top of massive cubes that hold up the upper level of the monument. The pillars form two niches, the left one containing *Contemplative Life* in monastic dress and with her hands joined, and the right one *Active Life* with a lau-

Fig. 36, detail.
Sybil.

Fig. 36, detail.
Contemplative Life.

Fig. 36, detail.
Active Life.

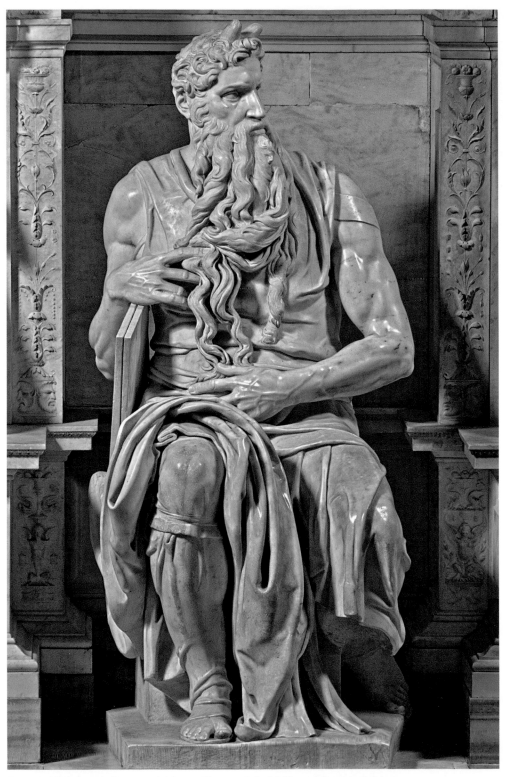

Fig. 37. *Michelangelo Buonarroti,* Moses. *Photograph by Mallio and Eugenio Falcioni.*

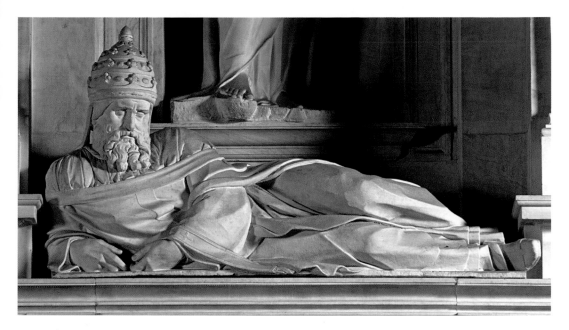

rel wreath in her hand and an ambiguous object inserted in her very long hair, while the figure of *Moses* is in the central space (fig. 37). The upper level is composed of very high pillars with *herms* serving as capitals and without any architectural crowning but which resemble lilies with slender candelabra over them. Arranged on the central axes are the *papal emblem*, the *Virgin with the Child* and the figure of the pope *Julius II* (fig.38) lying on the tomb and in the lateral spaces a *Prophet* and a *Sybil*: "messengers of the divine word to humanity". Four small rectangular windows with a grating (two are external to the monument) allowed the monks to see into the interior of the church while their singing during the mass could be heard through the lunette in the relieving arch.[63]

A vast literature has investigated the history of the monument. Recent restoration has led to further studies and new interpretations.[64] In particular, this work has been devoted to topics that will be summarized here. *Moses* the biblical figure of Christ, modified in 1542 on the left side, his head being turned away from the altars (figs 37 and 39) assumes a new meaning in the light of reflections on the justification by faith and the new issues raised by the Reformation.[65] The michelangolesque statue of Julius II, according to Vasari is the work of Tommaso Boscoli; the realism of the stern face with its penitent's beard and of the softly resting hands (figs. 38 and 40) go well beyond the simple retouching that was asked of the master. Then there is the complex iconography of the *Active Life* (on Moses' right) portraying Charity and the *Contemplative Life* (on the left) representing Faith, both virtues that lead to salvation. Finally the monument as a whole is an expression of the religious thought of Michelangelo, who was involved in the new spirituality of the group surrounding cardinal Reginald Pole, the papal legate to the Council of Trent.[66]

Fig. 38.
Michelangelo Buonarroti and Tommasso Boscoli, The pontiff Julius II reclining. *Photograph by Mallio and Eugenio Falcioni.*

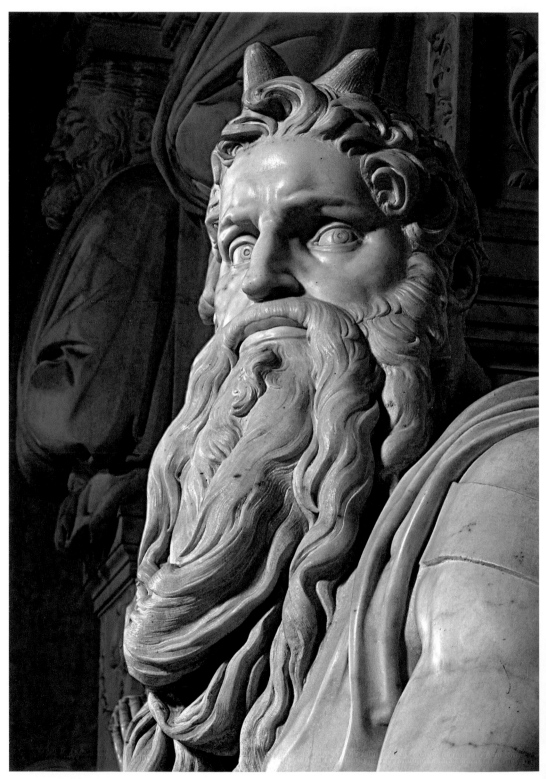

Fig. 39. *Michelangelo Buonarroti. Head of Moses. Photograph by Mallio and Eugenio Falcioni.*

Fig. 40. *Michelangelo Buonarroti. Head of Julius II. Photograph by Mallio and Eugenio Falcioni.*

XI. Pictorial Decorations of the Apse

The walls and the calotte of the apse are decorated by motifs that are related to the ancient relic of Saint Peter's chains, connected to the name of the basilica and to the story of the foundation of the church of San Salvatore dei Canonici Regolari in Bologna. The Roman congregation of the same Order depended on the Bolognese Congregation which Innocent VIII appointed as the head of the basilica in 1489. According to tradition the dedication of the Bolognese church to the Holy Saviour stemmed from the donation made by Innocent II of a vial of Christ's blood that had spurted out of a crucifix found in the home of a Jew in Beirut.[67] The Father-general of the Order Raffaele Campioni proposed the decorative programme to the Florentine artist Jacopo Coppi in 1577.

Between the two large rectangular windows are three episodes telling the story of the chains: *The Liberation of Saint Peter from Prison*; *the Patriarch of Jerusalem, Juvenal hands over the Chains to the Empress Eudoxia* (fig. 41); *Eudoxia donates the Chains to the Emperor*. According

Fig. 41. *Jacopo Coppi*, The Patriarch of Jerusalem Juvenal hands over Peter's chains to the empress Eudoxia. *Scene in the central panel of the apse (1577).*

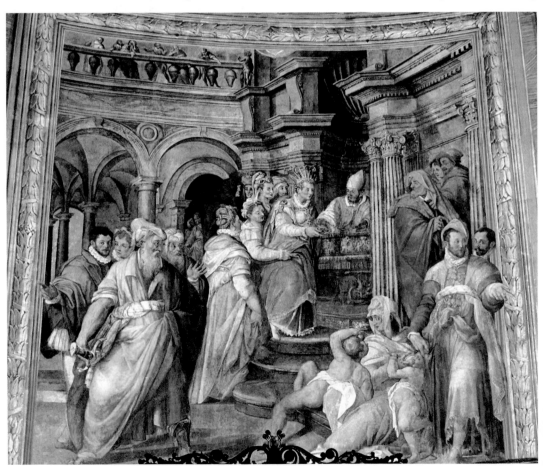

to the legend the chains that had held Peter prisoner in Jerusalem and which Eudoxia, mother of Theodosius II had requested and brought to Rome, handing them over to the pope, miraculously united with the chains that had bound Peter in Rome (see chapter V).[68] In telling the story visually Jacopo Coppi clearly draws on a Rafaellesque heritage and Tuscan culture.

The narration depicted in the apse's calotte is *The Miracle of the Crucifix of Beirut* (fig. 42).[69] The story was read out at the second Council of Nicea (787) which condemned iconoclasm and reinstated the cult of images. The event is recounted in six episodes on two levels identified by inscriptions. *Icon XPI invenitur:* a crucifix is found in the house of a Jew that had been left there by the Christian who had sold him the house; the fact was reported by some of the new owner's guests to the rabbis. *Crucifigitur:* the rabbis visit the home and in an act of sacrilege pierce the image with a lance. *Transfigitur e(t) sanguis auritur e(t) eo i(n)firmi cura(n)tur:* blood issued forth from the wounds and was collected in vials which healed many sick. [*Icona*] *metropolita(e) defertur:* the miraculous crucifix is shown to the bishop. *Sanguis distribuitur:* the vials with the precious relic were distributed. *Baptiza(n)tur et sinag(og)a in honore(m) S(anc)t(issim)i Salvatori co(n)secrat(ur)*: many Jews converted, accepted baptism and the synagogue became a church dedicated to the Holy Saviour. The vision of *Christ the Judge, the Virgin and Angels with Symbols of the Passion* concludes the cycle.

Fig. 42. *Jacopo Coppi,* Miracle of the Crucifix of Beirut. *Scene in the calotte of the apse (1577).*

The argument touches on the theme of salvation as shown in the baptism of the Jews and the blood of Christ collected in vials, symbols of the sacrament of the eucharist.

The Council of Trent reconfirmed the admissibility of images as visual messages of the Catholic faith as against the sole preaching of the Gospel which was the position of the reformed Church. The subject which covers a very limited portion of the apse's ceiling has the force of a sweeping narrative cycle: real space is fused together with imaginary space represented in majestic architecture in which large figures, nudes resembling sculptures, are placed in a dynamic perspective arrangement. Coppi's work stands out in comparison to other nearly contemporary cycles of paintings (Oratory of the Gonfalone, Oratory of the SS. Crucifix) in which artists from the area of Lombardy blended northern European culture with the heritage of Muziano and the Tuscan tradition.

XII. The Paintings on the Altars

XII. 1. *St. Augustine in Meditation*

The painting depicting St. Augustine in bishop's robes may be seen in the first altar of the right aisle (fig. 43). The seated saint is absorbed in the act of writing while behind him stand St. Monica and St. Agnes (?). The small child holding two vials is an iconographic reference to Augustine's meditation on the mystery of the Trinity that comes from a medieval tale: a child wished to empty the sea with a tiny receptacle. When Augustine explained that this was impossible to do, the divine

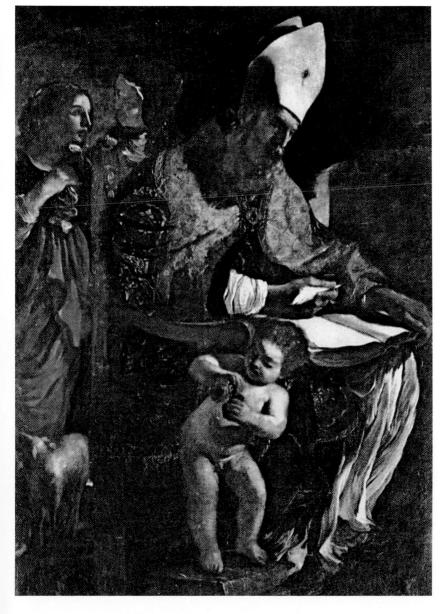

Fig. 43. *Giovanni Francesco Barbieri known as Il Guercino (attributed),* St. Augustine in Meditation between Sts. Monica and Agnes.

reply came from the child's mouth that it would take less time to empty the sea than for Augustine to explain the mystery of the Trinity. In the Apostolic Visit of 1628[70] the painting is indicated as being placed in the wall of the interior façade to the right of the main entrance: here it remained until 1682.

The canvass is heavily covered over by old paint and the faded colours obscure the design: it was restored that year by the painter Pietro Santi. The subject is associated with the Ordine Agostiniano dei Canonici Regolari del San Salvatore who governed the two monasteries of San Pietro in Vincoli and Saint Agnes outside the Walls. Saint Agnes' relics are kept in the sacristy.

The sources and recent scholarship attribute the painting to Guercino (Giovanni Francesco Barbieri, 1591-1666),[71] rather than to his pupil Benedetto Zallone.[72] It was probably done at the end of the 1620s: the commission may have been obtained through the influence of Canon Antonio Mirandola, the painter's patron.

XII. 2. *The Liberation of St. Peter from Prison*

The painting is over the second altar in the right aisle. The Canonici had it specially done by painter Pietro Santi at a cost of 25 scudi (fig. 44) The canvas with its strong contrasts between shadows and light is contemporary (1682-1683) with the altar. It derives from another painting of the same subject but a different size that was kept in the sacristy (today in another place).[73]

This other painting is an old copy of an original by Domenichino (Domenico Zampieri 1581-1641) that was housed in Potsdam[74] and lost during the Second World War. It was accurately described by Giovanni Pietro Bellori.[75] According to some biographers, Giovanni Battista Agucchi had Domenichino paint *The Liberation of St. Peter from Prison* (lost) in order to show it to Girolamo, cardinal-priest of the basilica, who considered the Bolognese painter to be mediocre. Girolamo, who had believed it to be the work of Annibale Caracci, was so surprised that he put it up on the high altar on August 1, 1604, pledging his patronage to the painter and a commission to paint the frescoes of *The Stories of St. Jerome* in the Roman church of St. Humphrey (Onofrius).

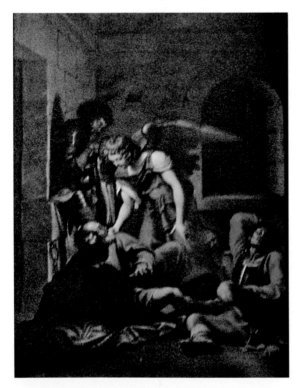

Fig. 44. *Copy by Pietro Santi,* Liberation of Peter from Prison *(1682).*

XII. 3. *Lament over the Dead Christ*

The painting is in the first altar on the left aisle (fig.45). Some 18th century guidebooks mention the presence of a "Pietà and Three Mary's" in the chapel of the transept of this aisle, and perhaps this was the painting's first location.

The painting follows a widespread convention in the post-Tridentine religious climate: a strong emotional charge emanates from the figures surrounding Christ who has just been taken down from the cross. The painter has simplified the faces and hardened the forms: late mannerist influences have been identified such as Cristoforo Roncalli, known as Pomarancio, or Giovanni Battista Ricci.[76]

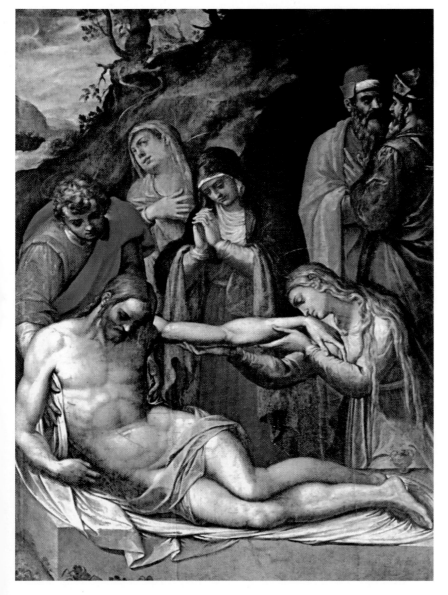

Fig. 45. *Unknown artist of the second half of the 17th century,* Lament over the Dead Christ.

XII. 4. *St. Margaret of Antioch*

The painting shows St. Margaret, a Christian martyr, who during her imprisonment was tempted or swallowed by (according to the *Golden Legend*) the devil, who is represented here as a dragon. Margaret aided only by the cross destroyed him or tore him to pieces (fig. 46).

The subject is connected to the name of the chapel whose patron was Eurialo Silvestri "relative" of Pope Paul III. The latter's coat of arms recently came to light after restoration work on the right pillar (2006).

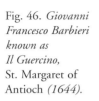

Fig. 46. *Giovanni Francesco Barbieri known as Il Guercino,* St. Margaret of Antioch *(1644).*

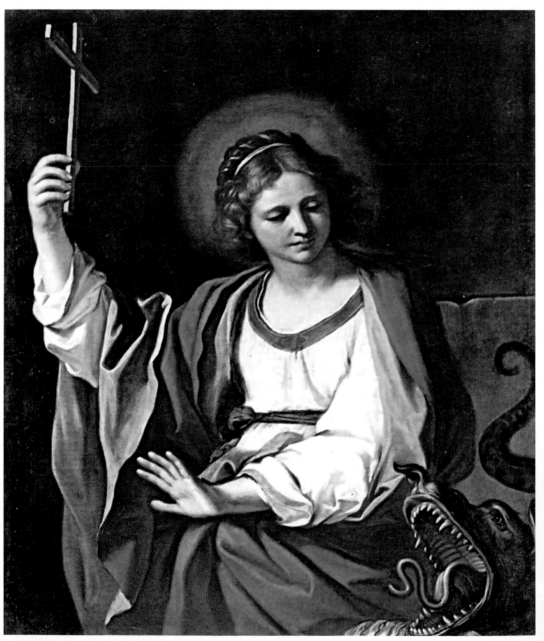

In order to build and enlarge his palace on the land given to him by the monks of Santa Maria Nova, the churches of Santa Maria de Arcu Aureo and Santa Margherita had to be demolished. To that end they were deconsecrated in 1547. In the Bull of November 12, 1547 Paul III granted a chapel with *jus patronatus* in San Pietro in Vincoli, to be dedicated to the Virgin Mary and St. Margaret. Euralio in his last will of November 29, 1549 wished to be buried in San Pietro in Vincoli in the chapel dedicated to "Marie arcus auri", in whose altar he had placed the *Nativity*. ([…] *in quo pro icona extat mysterium Smae Nativitatis Domini Nostri Jesu Christi*), still there in 1628 as mentioned in the Visita Apostolica.[77]

In 1566 his nephew and heir, Ascanio, promised to decorate the chapel and place within it a painting showing St. Margaret: a promise that was kept in a contract of 1567 made with two Sienese painters who executed *The Annunciation* and *Blessed Margaret* on the walls and *God the Father Almighty* on the ceiling.[78] These works probably disappeared, when cardinal Galli had decorations added to the two chapels of the transept in 1765.

The canvas is a documented work by Guercino (1644), commissioned for the "Father-General of San Salvatore", that is, of the Canonici-Regolari del San Salvatore of Bologna, who in that year was Tommasso Menzio and Menzio is therefore believed to be the commissioner.[79] However, the abbot Alfonso Pulcinelli, who had a good relationship with Guercino, may have played the role of middle man. The painting is sober in its composition of the figure and delicate in its use of colour, which features are characteristic of Guercino's mature period.

XIII. The Ceiling and Decorations of the Central Nave

XIII. 1. *The Ceiling*

On April 1, 1705 prince Giovanni Battista Pamphili donated six million pounds of sulfur to several Roman basilicas for the improvement of their old structures, specifying that the interventions in each church be done with regard for the early Christian forms.

The five hundred pounds assigned to San Pietro in Vincoli were to go to covering the wooden roof built with Nicola Cusano's legacy whose inscription may be read on a wooden beam currently above the right colonnade (fig.16, cf. chapter III, 3).

The work began immediately under the direction of architect Francesco Fontana (1668-1708) who had presented a design that, according to Titi[80], was a balanced solution between cost and execution (fig. 47). Excellent organization of the various master masons, carpenters, bricklayers and gilders led to the completion of the work by the end of the same year. The covering of wood "in veined marble" consists of a lacunar coffered ceiling divided into five bands marked by transversal panels. A median band running down the nave's longitudinal axis is divided by a rectangle with two scallops which is the location of the painting by Giovanni Battista Parodi (see next chapter), by two octagons with the coats of arms of the Pamphili family and Clement XI and two ovals bearing inscriptions.

Fig. 47. *Francesco Fontana, ceiling of the central nave (1705-1706).*

Fontana's innovative solution went beyond the widely used pattern of caisson ceilings: the dividing up of the surface into transversal sectors and the splayed polygonal lacunaria give the ceiling an illusory lightness that cancels out the great effect of the ancient hall.

Fig. 48. *Giovanni Battista Parodi,* Miracle of the Chains *(1705-1706).*

XIII. 2. *The Miracle of the Chains*

Cardinal-priest Marcello Durazzo donated "as alms" the painting in the centre of the ceiling, placing his coat of arms there (fig. 48).

The *Miracle of the Chains* is the first documented work in Rome (1705-1706) by Giovanni Battista Parodi (1674-1730).[81] The Genoese painter arranges his protagonists on a series of tiers against a background of highly foreshortened architecture that is a free rendering of the Petrine basilica. Above, the view of Peter and the angels interpenetrates with the arcade and the violet curtain. The painting portrays rather imaginatively the story told by Siegebert of Gembloux[82] of a miracle that occurred to a certain count at the court of Otto I. Possessed by evil spirits, he was ordered by the emperor to go to Rome to pope John XIII to free himself. The miracle occurred as soon as he touched the Holy Chains (see also chapter V).

XIV. The Organ

The sources have always indicated the organ (fig. 49) as being located against the back wall of the North side of the transept. Some sources from the basilica's archive[83] relate that the cardinal Antonio Carafa (1430-1511) in an act of generosity to several Roman churches and convents had an organ built at his expense. Cardinal Alessandro Cesarini († 1542) is mentioned by Ugonio[84] as donator of an organ and "other improvements to the sacristy", apparently the wooden door (see next chapter XV). The casing of the organ that we see today dates back to an agreement of August 8, 1686 between the Canons of the

Fig. 49. *The Organ (1687).*

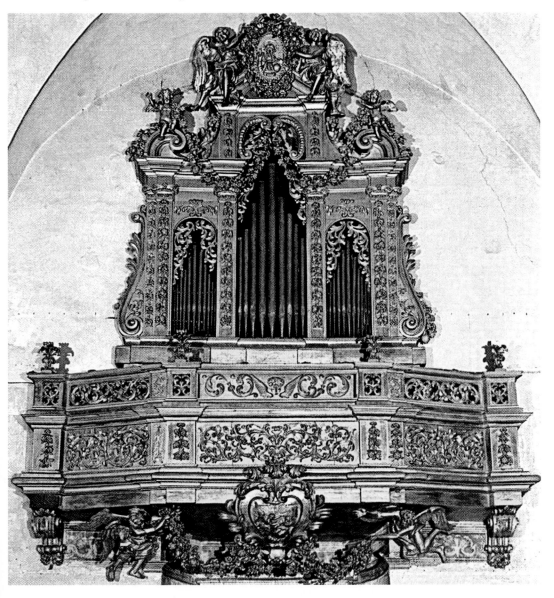

church and the woodcarver Lorenzo Barbieri who did the very elegant design and the decorative work with six statues, while the carpentry and inlay were done by Baldassare Mazzi and the gilding by Giuliano Bonasegni. The organ with seven pedals was built by Giacomo Alari,[85] founder of a family of organ builders who were active in Rome until the first half of the nineteenth century: he replaced the old instrument with a new one in 1687. The wooden casing in three bays encloses the pipes, and its pediment is adorned with festoons and angels: two of them hold up an oval with the emblem of the Canonici Regolari di San Salvatore, two sit gracefully on the volutes and two underneath the chancel support a festoon that rests on an oval with the representation of *Peter liberated by the Angel.*

[G.Z.]

XV. The Sacristy

XV. 1. *General Information and Patrons*

On the sides of the monument to Julius II two doors open providing access to two chambers that adjoin each other. The first of these is the antesacristy. The original passageway between the church and these rooms was that near the chapel of St. Margaret. On the inner side of the doorway, that is towards the antesacristy is the inscription *Giulio Cardinale di S. Pietro in Vincoli*; the second door dates to the 1960s; at that time and until a few years ago the antesacristy served as a souvenir shop besides being a picture-gallery.

Just after crossing through the two doors we come to the first large connecting room (fig. 50) with the length of the side of Julius II's tomb (around 11.8 m) and around 5.9 m high. The ceiling is in lunettes and on it are the arms of Sixtus IV and Giuliano della Rovere. Francesco

Fig. 50. *Antesacristy. Photograph by G. Castrovinci.*

della Rovere, future pope Sixtus IV who was appointed titular cardinal of San Pietro in Vincoli in 1467, immediately began the restoration work that the church needed. This work was financed by a legacy of cardinal Nicola Cusano along with subsidies from pope Paul II. Cardinal della Rovere's interest in the church continued even after he became pope and made his nephew Giuliano cardinal-priest in 1471. It was Giuliano, titular of the church from 1471 to 1503 and future pope Julius II who asked Sixtus IV's successor, Innocent VIII to entrust the complex of San Pietro in Vincoli to the Canonici Regolari del San Salvatore.

Very likely the list of works ordered by pope Sixtus IV and his nephew Giuliano included this connecting room which today we call the antesacristy. From here through a narrow staircase we climb to the upper floor; this other room was perhaps the modern *schola cantorum* . Back on the lower floor we can see that a trace of the original staircase remains visible on the floor and that this zone was linked to the refectory and the rest of the monastery.

Access to the sacristy is through a beautiful wooden door – part of a doorway that bears an inscription referring to the work commissioned by Galeotto Franciotti della Rovere between 1503 and 1508,[86] which was intended to enlarge this room. Fig. 51 shows the sacristy viewed from the entry door. The double doors are divided into four

Fig. 51. *Sacristy seen from the entrance. Photograph by G. Bartolozzi Casti.*

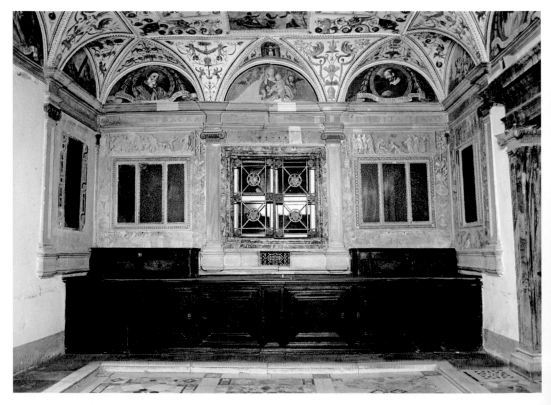

sections, two on each side with reliefs on the upper left depicting *St. Peter and the Angel* and on the upper right *St. Agnes.* Both reliefs are placed over a section with the coat of arms of the donor of the work (fig. 52).

Above and below the reliefs are four small rectangular sections bearing the carved letters of a dedicatory inscription by the Canons Regular to Peter in Chains and St. Agnes, virgin and martyr. The study by Alfredo Paolucci[87] besides solving the riddle of these letters, covered by a thick layer of paint, has identified the coat of arms on the door making it possible to assign a name to the patron, cardinal Alessandro Cesarini Senjore.[88]

Through this door one enters a medium-sized room, square in shape – 5.55 m x 6.3 m; 4.8 m high – with a ceiling with lunettes and a small chapel on the right wall. The back wall which has a shrine at its centre for relics (on the other side) closed off by a grating has a beautiful cornice of jasper red Sicilian marble built in the 18th century – and the walls perpendicular to it are decorated in marble panels: tripartite panels on the walls opposite the entrance and single on the side walls framed by narrow strips of mosaics. The entablature bears an inscription indicating that the function of the room was to store things sacred to God with the date 1523: *quae sunt sacra/deo hic intus/condita servo/MDXXIII.* This room must have played a role of great significance for the entire monumental complex of San Pietro in Vincoli.[89] In fact, what is today called the "sacristy" as reported in the record books of the Canonical Order and the basilica from the early 1640s, must originally have been the place where St. Peter's chains were kept, as we may gather from the inscription.

Behind the commissioning of the work and the choice of its decoration, which we shall see, was not just the Canonical Order but

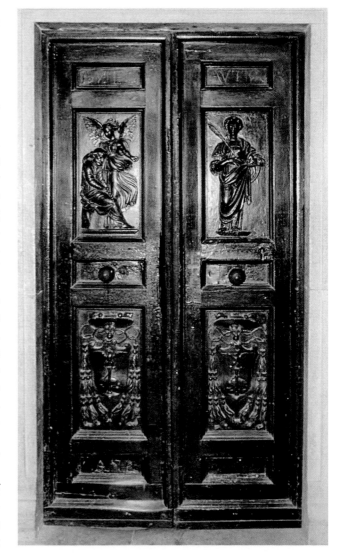

Fig. 52. *Door to the sacristy. Photograph by G. Castrovinci.*

also and above all a leading figure, probably cardinal Albert of Bran-
denburg, cardinal-priest of the basilica from 1521 to 1545. The latter
may have proposed an initial overall project: the costly ornamentation
and the motifs of the paintings suggest that this was destined to be "the
room for the relics". The chains of St. Peter are documented in the sac-
risty only as of 1662; they remained there until 1877, when the *crypt*
was completed with the new high altar (see chapter VI.2).

XV. 2. *The Floors*

The two rooms still have their original floors. The few specialized
studies on the basilica that mention the floors, frequently use the ad-
jective "Cosmatesque" to describe them. However, in both rooms the
term is not appropriate: the pattern, in fact, only corresponds to a
very loose interpretation of a Cosmatesque floor. But were those who
laid the floors of St. Peter in Chains aware that their work might rep-
resent a stylistic innovation in the field of marble inlay? Did the peo-
ple who commissioned it, i.e. Pope Sixtus IV and his nephew Giu-
liano, contribute to its design or did they give the marble workers
carte blanche?

Unfortunately the studies in this field are of little use. Between the
Cosmati and the Renaissance there is almost a hundred-year gap in the
history of marble floors in Roman churches.

The very elegant mosaic floor of the antesacristy with its geo-
metric inlay work (fig.53) likely dates to the della Rovere interven-
tions of the 1470s. The marble used here, like that in the sacristy,
which we will see later, appears at first sight to be reused material.
This is quite possible: Colini suggests that the marble workers may
have used material from the ancient Roman *domus* underneath the
basilica.

What remains of the floor in the antesacristy, believed to be
from the period of Giuliano della Rovere, titular cardinal of San
Pietro in Vincoli from 1471 to 1503 may be considered a transi-
tional period from the Cosmatesque art – which ended when the
papacy moved to Avignon – to that of the high Renaissance when
artists began using small and medium-sized coloured pieces of mar-
ble in a new way, drawing their inspiration from the geometric de-
signs of the Cosmati.

A detail in this floor (fig.54) has been linked for the first time by
Giuliana Zandri[90] to a drawing in the sketch-book dated 1554 belong-
ing to Giovanni Colonna da Tivoli[91]. The page in question contains a
drawing of the floor plan of the cloister, some details of the well and
the geometric motif of the floor. The drawing shows an additional dec-
orative detail that does not appear in the section of floor reproduced
here: probably the artist began the drawing based on a previous sketch
but then finished it later from memory.

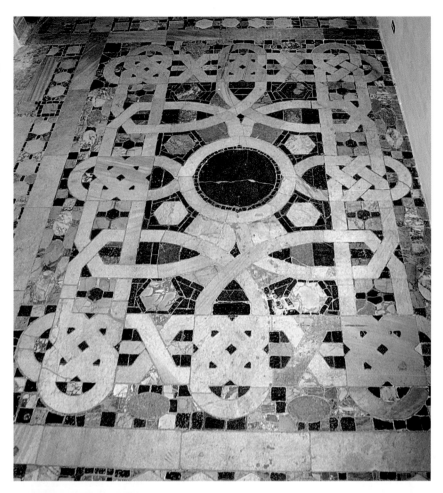

Fig. 53. *Antesacristy, view in perspective of floor. Photograph by G. Castrovinci.*

Fig. 54. *Antesacristy, detail of floor. Photograph by G. Castrovinci.*

The interlacing patterns that decorate the corners of the floor form what is known as a *Solomon's Knot* (fig.55), a sort of interlinking loop closed into a ring, in which it is difficult to discern the beginning and the end. This is an ancient symbol which many legends trace back to King Solomon. Iconographically, the symbol's structure is simple: in the classic form two flattened rings are joined at right angles like links in a chain that make a cruciform design. This pattern has dozens of variations. Embedded in this symbol are even more ancient ones, like the swastika - the cruciform wheel that alludes to cosmic dynamism – the spiral or cyclical evolution, as well as the cross and the six pointed star or "Solomon's Seal"; the motif possesses a deep spiritual significance and may be considered the graphic paradigm of the intersection between the transcendent and the immanent world or the difficult quest for salvation and the absolute. The image of the knot indirectly expresses and establishes a union. However, there are two possible meanings: a positive one if the link created is with a higher power that implicitly has the magical power to protect, and a negative one in the sense of "imprisonment" if the link is of a lower order or a vehicle for soothsaying and magical practices.[92]

Fig. 55. *Giovanni Colonna da Tivoli, motif resembling a detail in the floor of the antesacristy. Image from M.E. Micheli.*

The floor of the sacristy (fig. 56) presents an elegant pattern of white marble squares decorated with polychrome pieces in geometrical forms. In the central part of the floor a marble insert in the shape of an almond mirrors the painting above it located in the oval at the centre of the ceiling. But both patron and marble workers sought to maintain a kind of similarity between this floor and the one that was presumably in the church at the time. As Giuliana Zandri has observed, the floor of the sacristy is "an elegant covering of antiquarian taste",[93] a free rendering of the Cosmatesque style, just like that of the antesacristy, the last surviving portion of a vast mosaic floor; in fact, the marbles used are the same type and colour as in the antesacristy.

Again there is no information about when the floor was laid but a document dated May 1661 may refer to the year in which the work was executed.[94]

Fig. 56. *View in perspective of sacristy floor. Photograph by G. Castrovinci.*

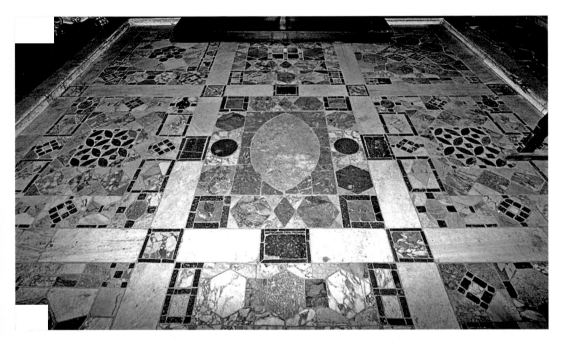

XV. 3. *The Frescoes*

As mentioned above, behind the commissioning of the work and the choice of its decoration was not just the Canonical Order but also, and above all, an important personage, probably cardinal Albert of Brandenburg. Titular cardinal of the basilica in that period, he may have proposed an initial overall project. In fact, the costly ornamentation and the motifs of the paintings suggest that this was destined to be "the room for the relics".

The decoration of the back wall continues above and below three of the four marble panels: scenes from the life of St. Peter are painted in monochrome, today unfortunately not all are legible because of the poor state of conservation; the panel on the left wall is completely without paint.

The monochrome paintings in the other panels represent scenes from the life of St. Peter and they are all placed in the upper level: *Peter wounds Malchus, Servant of the High Priest* (fig.57); *The Washing of the Feet* (fig. 58); *Jesus hands the keys to Peter* (fig.59). Giuliana Zandri[95] has advanced proposals for reading those scenes that are difficult to interpret since they have lost their colour – shown in section below the two panels in the longer wall, that is, the back wall: *The Calling of Peter*. This scene is more decipherable than *The Resurrection of Tabitha* which is almost completely lost; even if a few traces of colour are still visible on the latter, it looks as if it was painted over later to compensate for the fading colour. Finally, the third subject in the band underneath the panel of the right wall is not clearly identifiable; it was painted over probably in more recent times.

Fig. 57. *Polidoro Caldarra (attributed)*, Peter wounds Malchus, servant of the High Priest. *Photograph by G. Castrovinci.*

Adorning the edges of the marble panels are beautiful candelabras, also painted in monochrome, depicting papal tiaras, bishops' mitres and liturgical symbols. After closely examining the three surviving stories in monochrome and the candelabras, the present author has suggested attributing them to Polidoro Caldara di Caravaggio (1495/1500-1543). The closest parallel is with the rooms of Alexander

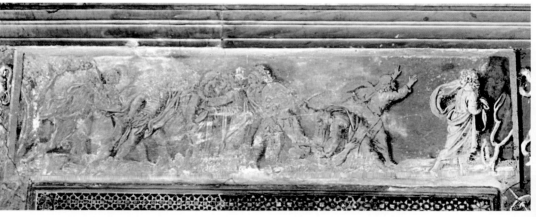

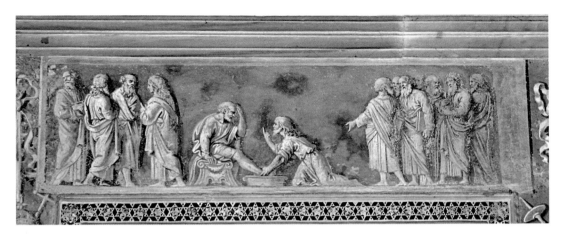

and Roxana in the Farnesina, datable to around 1519 where Polidoro was working with his faithful companion Maturino, under the direction of Baldassare Peruzzi.[96]

In the monochromes of the sacristy, datable to approximately between 1525 and 1527 the formal execution closely follows that of the earlier Farnesina room, though here the treatment of the figures has greatly improved, a fact which is also noticeable in the Room of Constantine in the Vatican which marks an important watershed between the two works mentioned. Indeed, nearly six years elapsed between 1519 and the period we can date the sacristy's monochrome; the gap may be explained by events from Polidoro's biography that rule out any activity in Rome between the summer of 1522 and that of 1523.

Looking up at the ceiling (fig. 60), we find that a vivid grotesque decoration spreads out against a white background – with slender aedicules and small sacred temples, *putti* among flowers and bearing cornucopia, mythological monsters and birds – immersing the visitor in a fantastic world inhabited by animals, imaginary figures, bucolic landscapes and still lifes which made this type of decoration

Fig. 58. *Polidoro Caldarra (attributed)*, The Washing of the Feet. *Photograph by G. Castrovinci.*

Fig. 59. *Polidoro Caldarra (attributed)*, Jesus hands the keys to Peter. *Photograph by G. Castrovinci.*

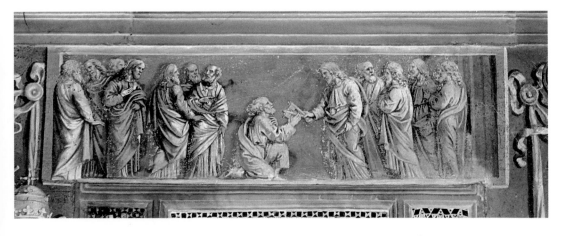

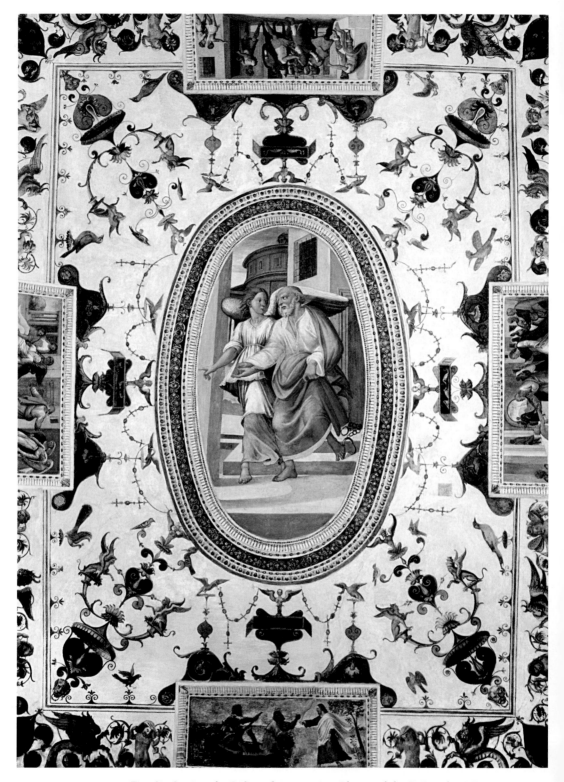

Fig. 60. *Sacristy, the Ceiling after restoration. Photograph by G. Bartolozzi Casti.*

so popular[97]. The grotesques on the ceiling serve as a frame for five paintings: in the central oval we have *St. Peter and the Angel.*[98] On the four sides, four scenes from the life of St. Peter: *The Calling of Peter,* the *Healing of the Lame Beggar, the Deaths of Ananias and Sapphira* and *The Condemnation of St. Peter.* In the opinion of the present author, these pictures, which also date to between 1525 and 1527, were not done by Polidoro or his friend Maturino, or at least not entirely by them, but by Vincenzo Tamagni da San Gimignano (1492- post 1530), who was an old acquaintance of Polidoro's from the time they worked together in the Bibbiena Loggia at the Vatican (1515-1517[99]).

The grotesques also fill the pendentives between the lunettes. The latter contain a depiction of a *Virgin and Child,*[100] illustrious members of the Congregation of the Canons Regular of the Rhine, and Saints between *clipei* and festoons of laurel and scroll ornaments with inscriptions identifying the subject represented and finally pairs of *putti* playing with and holding papal symbols like the cross, the tiara and the keys, and Petrine symbols like the chains and the upside down cross.

The personages shown in the lunettes are, starting from those on the wall facing the entrance: *St. Guarino Cardinal* and *St. Gelasius Pope,* to the sides of the lunette with the Virgin; on the right wall *St. Anianus Bishop of Orleans,* and *Bishop Ubaldo;* on the entrance wall *Blessed Stephen of Siena* and *Blessed Archangel Bonon.* Finally, on the right wall *St. Fulk Bishop* and *St. Aquilinus Martyr.* The lunettes with the abovementioned personages and those with the *putti* show the presence of a hand and style that is profoundly different from the rest of the decoration and is certainly datable to well into the 17th century. The documentary sources have provided a name that may possibly be associated with this work, a certain Ottavio Mazzienti, who was a painter and who appears in 1661 as having been paid the sum of thirty scudi for a painting in the sacristy. However, unlike the others, one of the *putti* was painted on canvas: that is the one placed at the centre of the inner side of the entrance wall in which two *putti* hold up the emblem of the Congregation which was founded in 1823 by the Canons Regular del Santissimo Salvatore Lateranense. The ceiling decorations and the lunette just described were restored in 2012 by Rossano Pizzinelli and his team.

XV. 4. *The Chapel*

The right wall of the sacristy opens into a small chapel (fig.61) with an altar done in pseudo- cosmatesque style and supported by two spiral columns inlaid with mosaics that perhaps came from some other dismantled altar within the church; on the altar-dossal we have another tripartite panel with a frame in mosaics into which a marble slab has been inserted representing a *Virgin and Child.* Both the dossal and the

Fig. 61. *Chapel on the right side of the Sacristy.* Photograph by *G. Bartolozzi Casti.*

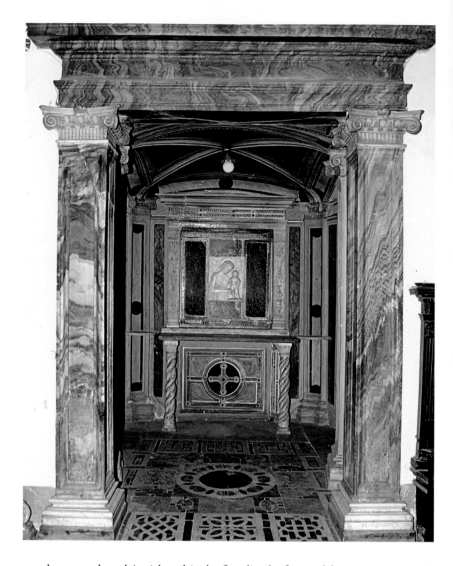

panel are enclosed inside a kind of aedicule formed by two square pilasters that support an architrave bearing two strips of mosaics.

The decoration of the chapel took longer to complete than its surroundings; the documents consulted only give information on the paintings – presumably of the walls painted in *faux* marble and the vault decorated with a starry sky – executed by Michele Ottaviani between 1861 and 1862. Ottaviani, painter-decorator from Fermo was active in Rome at the basilica of Saints Boniface and Alexis on the Aventine hill between 1852 and 1860, where he did the decorations of the ceiling of the central nave and the chapel of St. Girolamo Emiliani.

Of great interest is the beautiful marble panel of the *Virgin with the Child* (fig. 62) situated above the altar table, which I believe should be attributed to Mino da Fiesole (1429-1484).[101] The overall execution of

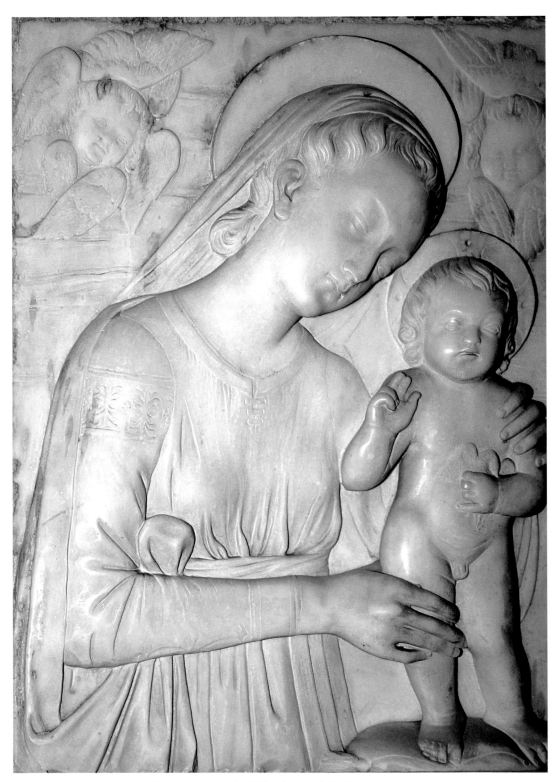

Fig. 62. *Mino da Fiesole (attributed)*, Virgin and Child. *Photograph by G. Castrovinci.*

the altar-piece in the chapel reveal Mino's characteristic style. The Virgin's face and posture may be found in other works of the sculptor dealing with the same subject. The long and slender neck and its unnatural twisting together with the pronounced and unnatural flatness of the Madonna's arm recur like a stylistic formula in other works by Mino da Fiesole. While the execution of the garments may seem schematic and without plasticity, possibly the result of an intervention in the workshop, the type remains the same: in our Virgin the smoothness of the drapery emerges rigorously while renouncing two dimensionality to create an effect that dresses rather than constrains.[102]

However, the posture of the Child in our marble panel is different from that in similar subjects by Mino. The Child's pretty, puffy face is framed by the soft lines of his hair as his mother delicately holds him up. In fact, the Child is shown standing on a cushion and he is holding a bird tightly in his hand, presumably a goldfinch - one of the symbols used to portray the child Jesus in painting and sculpture. Here the goldfinch has the same significance it had in pagan religion, where it symbolized man's soul which at the moment of death flies away. By contrast, the fingers of the child's right hand are giving a blessing. The strong and yet delicate figures are animated in an almost pictorial effect by a diffuse luminosity. The marble refines itself into a compact surface from which a restrained tension emanates. The documents make no mention of this panel: the author suggests that it may have been bequeathed to the church by some benefactor, perhaps one of the cardinal-priests.[103]

[R.C.]

XVI. Appendix

Digital Methods for Graphic Reproductions

It must be said in advance that the compound of St. Peter in Chains contains in a limited area one of the most complex and perhaps chronologically complete archaeological palimpsests in Rome[104] (see especially chapters II and III). Historical periods succeed each other in a dense sequence: Republic, Principate, Late Antiquity, Middle Ages and Renaissance. It is especially the oldest sections, before the church was built, that are hardest to access, and hence to interpret, as they were effectively sealed off after the closing of the excavations by the new floor.[105] Moreover, after the excavations the archaeological remains have not found a permanent location for display. We have therefore decided to offer the reader a certain number of graphic reconstructions that represent the likeliest hypotheses while providing an immediate picture.

According to our agreement with the curator and under his direction, it was important for us to use digital instruments and methods to obtain three dimensional graphic reproductions both of the earliest non-ecclesiastical periods and of the church built after the initial instabilities, later restorations and new discoveries.[106] Advances have led to the wide use of multimedia technologies in the fields of architecture and archaeology and the coining of the expression "Virtual Heritage" to refer to software for the 3D modeling of historic buildings or archaeological sites that can give an immediate picture of the monument.

To perform this operation it was of vital importance to draw a scaled image of the current basilica and compare this with period images[107] and information from archive documents of sales or letters by historical figures who were involved in the basilica. A large portion of these documents are to be found in the *Archivio storico* housed on the second floor of the cardinal's palace of San Pietro in Vincoli.

The building was modelled using four types of software: *Autocad 2011* for the design of the floor plan; *Google Sketchup* for its simplicity in modelling primitive solids and exporting two dimensional profiles; *Adobe Photoshop cs5* to modify the textures (maps for spreading surfaces) using patterns assigned to the functions of tiles, bump and displacement (three dimensional maps) and *3D StudioMax* optimized with *V-Ray* for hyper-realistic rendering while taking care to correctly calculate the caustics of indirect illumination.

The reconstruction was made possible thanks to the recent important archaeological discoveries that were subject to careful study.[108]

Archaeological excavations (1957-1959) made it possible to identify the outline of the reconstructed church (Sixtus III, 432-440) by studying its foundations. Those of the North side have revealed significant instances of overlapping of the two churches indicating restora-

tion work in brick of modulus 34-36 with an interval of 2.45 m to a level higher (0.15-0.20m) than the previous construction.[109]

Sixtus III's early Christian construction by and large corresponded to the dimensions of today's church. It had a three-aisle structure (61 x 28.5m), divided by twenty monolithic Dorian columns of grey Aegean veined marble supporting the arcades over which rose the brick walls with windows and two columns of grey granite resting against cruciform pillars with Corinthian capitals. The central nave (38 x 16m) was bounded on the North-East by a transept that was added during the reconstruction and illuminated by two large windows over the arcade.

The terrace located between the cardinal's palace and the basilica still clearly shows that only six of the eleven windows preserve their original shape.

The windows on the South side today are enclosed in the rooms of the Engineering Faculty and therefore are not visible from the outside.

The "open" façade of the first construction was modified, closing the five openings and the circular windows and leaving a central door and two side doors, perhaps closed in the 15th century.

We know for certain that the ancient church possessed a narthex. This was customary, so as to protect the faithful from inclement weather. Clear evidence for this is to be had from a notary's document on the cost of repairs reported by Tomassetti.[110] The presence of a narthex is also confirmed by the perspective plans of Fazio degli Uberti (1447) and Alessandro Strozzi (1474) mentioned above; especially that of Fazio degli Uberti which is certainly earlier than the construction of the portico that substituted the narthex. To reconstruct it we drew on other narthexes of the period, especially that of San Vitale, which is slightly older than ours and which was the subject of meticulous study by Krautheimer.[111]

The transept was composed of two lateral wings adjacent to the apse, without the two current windows. The North wing had a trapezoidal shape due to the use of the ancient foundations in a direction running parallel to Via delle Sette Sale. It was illuminated by no less than four windows, two in the front and two at the sides. The South wing which was long ago destroyed and distorted by the historical stratifications was reconstructed hypothetically with a more regular shape and with the same apertures as in the North wing.

In the attic one can see the medieval tripartition of the transept due to the work of reinforcement in the supporting pillar of the North arch, which was eliminated when the della Rovere rebuilt the vault and the South arch only partly hidden and obliterated by the same vault (see chapter III, 3).

Sixtus III not only created baptisteries for all of the churches that he built (Santa Maria Maggiore, Santa Sabina and San Lorenzo in Lucina),

but also carried out a complete renovation of the Lateran baptistery[112]. The probable existence of a baptistery also at San Pietro in Vincoli has been confirmed by the recent discovery of its monumental entryway. In fact, during recent restoration work in the cloister of the monastery, the South lateral nave was revealed to have windows in the aisles belonging to the first construction and a large triforium giving direct access to the baptistery itself, which no longer exists because of the construction and subsequent reconstructions of the monastery adjoining the south side of the church[113], and which today is occupied by the Faculty of Engineering of the University of Rome "La Sapienza". The previous existence of a classical building (see chapter IV) would have prevented any other arrangement of buildings than that in the reconstruction in fig.19a,b, which are shown aligned along the church's South perimeter walls. The presence of this building would not have allowed a southward expansion of the baptismal complex. Our reconstruction also refers to existing presbyterial baptisteries, especially that of San Clemente.[114]

[E.R.]

References

1. *"Salutate Priscam et Aquilam adiutores meos in Christo Iesu [...] et domesticam eorum Ecclesiam"*. Rom. 16, 3-5.

2. Phil, 4, 22.

3. Precursor of the theory was Kirsch. On this problem and on the different sometimes conflicting positions: KIRSCH 1918; PIETRI 1989. A lucid exposition in PANI ERMINI 1992.

4. COLINI - MATTHIAE 1966; *CBCR*, II, 1971, pp. 179-234: Krautheimer was able to carry out studies while the excavations were still going on.

5. MORRICONE MATINI 1980, p. 28.

6. Cf. AURIGEMMA 1961, pp. 150-154.

7. The interesting and important topic of the apsidal hall in relation to Christian places of worship above is examined by Krautheimer in his *CBCR*; Guidobaldi did a general study GUIDOBALDI 1986.

8. *ICUR*, II, 1, *passim*; BARTOLOZZI CASTI 1998, pp. 55-69.

9. MATTHIAE 1957; BARTOLOZZI CASTI 2002, with the previous bibliography.

10. Director of the works, arch. Raffaele Maria Viola, official of the Department of Archaeological Heritage in Rome.

11. BARTOLOZZI CASTI 1995-1996.

12. BARTOLOZZI CASTI 1998, p. 55.

13. MANSI 1760, coll. 1303-1304.

14. BARTOLOZZI CASTI 1998, p. 62.

15. For an in-depth look at the interesting and, in some respects, unique pillars (or small architraves) see: BARTOLOZZI CASTI 2002, pp. 354-355.

16. The basilica was built by cardinal Giovanni da Crema who consecrated it in 1129.

17. The certain chronology of the intervention rules out the hypothesis that the damage that was repaired had been caused by the militia of Robert of Guiscard whose invasion had occurred a century and a half before.

18. VENANZI 1953, p. 37.

19. By initiative of the SBAPR during the restoration of the cloister, directed by arch. Raffaele Maria Viola.

20. See BARTOLOZZI CASTI 1995-1996.

21. FERRUA 1939; BARTOLOZZI CASTI 1999, with the previous bibliography.

22. FELLETTI MAJ 1950, pp. 308-319; COLINI - MATTHIAE 1966, pp. 49-50.

23. CHAVESSE 1958, pp. 332, 334-338. On the whole question see BARTOLOZZI CASTI 2002, p. 955.

24. In the fifth century presbyters had been given permission to administer the Eucharist, but in the species previously consecrated by the Bishop of Rome (*fermentum*). On the topic: SAXER 1989, pp. 924-932.

25. I would like to thank Mons. Prof. Lorenzo Dattrino for his advice with regard to liturgy.

26. The analysis was carried out by the Studio associato LIMES-LAB - Servizi di Ingegneria (Ing. G. Sola, Arch. E. Roio, Geom. L. Sovrano).

27. *Inlesas olim servant haec tecta catenas/vincla sacrata Petri ferrum pretiosius auro* ("Under this roof the Holy Chains of Peter have long been kept intact: iron more precious than gold"). *ICUR*, II, 1, pp. 134, 157, 352, 410.

28. The entire topic is dealt with extensively in BARTOLOZZI CASTI 1997.

29. BARTOLOZZI CASTI 2003-2004, pp. 345-364.

30. On the question: BARTOLOZZI CASTI 1998, pp. 64-65.

31. UGONIO 1588, p. 55.

32. 2 *Maccabees* 7.

33. For a more extensive treatment see. BARTOLOZZI CASTI 2001; Ws, pl. 114, nos. 4 and 5.

34. Biblioteca Apostolica Vaticana, *Cod. Vat. Lat.* 3536.

35. *Act.* 12, 6-11.

36. ALBERTINI 1510, p. 47.

37. UGONIO 1588, p. 55.

38. CAVALLARO 2000, p. 402-406.

39. ZANDER 2010, pp. 3-33 (26-27);

40. *Liber pontificalis,* (ed. L. Duchesne), I, p. 350.

41. PAULI DIACONI, *De historia Langobardorum,* VI, 5.

42. AMORE 1975, p. 174.

43. BARTOLOZZI CASTI 2003-2004.

44. CURZI 1998, pp. 267-282, with previous bibliography.

45. See chapter VI, 1.

46. DELOGU 2001, pp. 18-21.

47. VENDITTELLI 2004, pp. 69-80

48. MATTHIAE 1987, followed by subsequent authors.

49. See more on the topic: BARTOLOZZI CASTI 2003-2004, pp. 379-401.

50. Biblioteca Apostolica Vaticana, *Cod. Vat. Lat.* 5408, f. 54r.

51. ZANDRI 1999.

52. *Ibid.*

53. Biblioteca Apostolica Vaticana, *Misc. Arm. VII,* ff. 430-435, especially f. 431

54. CASTROVINCI 2009 p. 56, fig. 12.

55. ZANDRI 1998, p. 110.

56. For a chronological summary of the various locations of the chains in the church see chapter V, 1.

57. Biblioteca Apostolica Vaticana, *Cod. Vat. Lat. 11905* .

58. ZANDRI 2000 a, pp. 118-125; TRITZ 2008, pp. 263-328, *passim.*

59. CAGLIOTI 2005. pp. 402-410.

60. FROMMEL 1977, pp. 36-43.

61. DE TOLNAY 1945 -1960, IV, p. 49-51.

62. ECHINGER MAURACH 2003.

63. VASARI 1568, p. 1230.

64. FORCELLINO 2002. For the restoration: Draghi - Viola 2003 a; Draghi - Viola 2003 b.

65. FROMMEL 2001.

66. FORCELLINO 2009.

67. TROMBELLI 1752, p. 62-63, 260-261.

68. BARTOLOZZI CASTI 1997, pp. 18-27.

69. *PG,* XXVIII, coll. 277-819.

70. Biblioteca Apostolica Vaticana, *Misc. Arm., VII,* ff. 430-435.

71. JOANNIDES 1996, pp. 18-19; Pulini 2003, pp. 73-74.

72. SALERNO 1988, p. 430.

73. GIAMPAOLI 1884, p. 66.

74. SPEAR 1982, pp. 133-134.

75. BELLORI 1672, I, pp. 309-310.

76. STRINATI 1969, pp. 15-16.

77. Biblioteca Apostolica Vaticana, *Misc. Arm. VII,* ff. 430-435 (431).

78, NAPOLETANO 2009, p. 10.

79. GALLO 2007, pp. 211-230.

80. TITI 1721, pp. 258-259.

81. BARTOLOZZI CASTI - ZANDRI 1999, p. 158.

82. *PL,* CLX, col. 80.

83. ZANDRI 2000 b, p. 127; ASPV, busta A955, f. 84.

84. UGONIO 1588, p. 55.

85. LUCCICHENTI 1989, pp. 15 -16.

86. Son of Luchinetta, sister of Julius II and Giovan Francesco Franciotti, he was the pope's favourite nephew who made him a cardinal at a very young age. He was cardinal-priest of San Pietro in Vincoli from 1503 to 1508.

87. PAOLUCCI 1932, pp. 25-32.

88. Alessandro Cesarini Senjore was not cardinal-priest of San Pietro in Vincoli; the connection with our church very likely derives from the proximity of the basilica and several residences built by his family which he must have often visited.

89. BARTOLOZZI CASTI - ZANDRI 1999, pp. 221-225.

90. ZANDRI 1998, pp. 91-118.

91. MICHELI 1982.

92. Scholars and enthusiasts of hermeneutics claim that it was in Celtic culture where this symbol originated and was most popular in which knots, interlacements and undulating figures were the underlying patterns of the symbolic-decorative form. From here influences reached the Roman world, especially the art of mosaic.

93. BARTOLOZZI CASTI - ZANDRI 1999, p. 258.

94. Giampaoli 1884.

95. BARTOLOZZI CASTI - ZANDRI 1999, p. 224.

96. CASTROVINCI 2007, pp. 9-30.

97. The *grotesques* of the *Cinquecento* adopted elements of ancient decoration, introducing new subjects and reinterpreting the models; this was done by Giovanni da Udine whose reflection on the grotesque "in harmonious fusion of imitation of the ancients and naturalism" influenced an artist like Polidoro da Caravaggio – the most important exponent of this type of decoration in Rome between 1516 and 1520.

98. Abbot Filippo Titi in his *Ammaestramento utile e curioso* (1686) probably referring to the painting mentioned and the four scenes on the perimeter of the ceiling attributes the work to Paris Nogari.

99. CASTROVINCI 2007, pp. 9-30.

100. The fresco again shows the hand of the same Polidoro, which even if partly repainted, retains some stylistic peculiarities of Caldara: the shape of the nose and the large eyes hearken back to the type adopted by Polidoro in the *Maddalena* in the chapel of Fra' Mariano a San Silvestra al Quirinale.

101. The figure of Mino da Fiesole has been and still is of interest to critics. Above all, scholars continue to wonder about the historical identity of the sculptor known as "Mino del Reame" or "Mino del Regno", a character introduced by Giorgio Vasari in one of his *Lives*. SCIOLLA 1970; CAGLIOTI 1991.

102. CASTROVINCI 2004-2005.

103. CASTROVINCI 2004-2005.

104. BARTOLOZZI CASTI 2005.

105. COLINI - MATTHIAE 1966; *CBCR*, III, pp. 186-234.

106. BARTOLOZZI CASTI 1995-1996.

107. Particularly useful: FRUTAZ *Piante,* II, tab. 153 (Fazio degli Uberti, 1447); *Ibid.,* tab. 159 (Alessandro Strozzi, 1474).

108. BARTOLOZZI CASTI 1995-1996.

109. BARTOLOZZI CASTI 2005, p. 8 , fig. 4.

110. G. TOMASSETTI, *La campagna romana*, IV, p. 77.

111. *CBCR*, IV, pp. 303-306, figs. 252, 256, 259.

112. BARTOLOZZI CASTI 1999.

113. BARTOLOZZI CASTI 1995-1996.

114. GUIDOBALDI - LALLI - LAGANELLI - ANGELELLI 2004, pp. 403-414, fig. 8a.

Bibliography and Abbreviations

ALBERTINI 1510
F. Albertini , *Opusculum de mirabilibus novae et veteris urbis Romae*, Romae 1510.

ALCIATI 1990
G. Alciati, *I papi costruttori. Storia e arte di Roma dall'Umanesimo al Barocco*, Rome 1990.

Altare monumentale
Altare monumentale delle catene di s. Pietro e cripta dei santi fratelli Maccabei nella basilica Eudossiana di S. Pietro in Vincoli inaugurati in occasione del Giubileo episcopale di S.S. papa Pio IX il giorno di Pentecoste del 1877, no date or place of the edition (Printed text at the Archive of San Pietro in Vincoli).

AMORE 1975
A. Amore, *I martiri di Roma*, Rome 1975.

ASPV
Archive of San Pietro in Vincoli.

AURIGEMMA 1961
S. Aurigemma, *Villa Adriana,* Rome 1961.

BARTOLOZZI CASTI 1995-1996
G. Bartolozzi Casti, "San Pietro in Vincoli: nuove scoperte", in *Atti della Pontificia Accademia Romana di Archeologia. Rendiconti,* 68 (1995-1996), pp. 333-338.

BARTOLOZZI CASTI 1997
G. Bartolozzi Casti, "Le catene di S. Pietro in Vincoli e la Prefettura Urbana. Riscontri storici e topografici, sviluppo della leggenda", in *Archivio della Società Romana di Storia Patria,* 120 (1997), pp. 5-34.

BARTOLOZZI CASTI 1998
G. Bartolozzi Casti, "Epigrafi scomparse di S. Pietro in Vincoli", in *"Domum tuam dilexi". Miscellanea in onore di Aldo Nestori,* Vatican City 1998, pp. 55-69.

BARTOLOZZI CASTI 1999
G. Bartolozzi Casti, "Battisteri presbiteriali in Roma: un nuovo intervento di Sisto III"?, in *Studi Romani,* 47 (1999), pp. 270-288.

BARTOLOZZI CASTI 2000
G. Bartolozzi Casti, *"Titulus Apostolorum"* - S. Pietro in Vincoli, in L. Pani Ermini (cur.), *Christiana loca,* Catalogue of the Exhibition (September 5 - November 15 2000), II, Rome 2000, pp. 192-196.

BARTOLOZZI CASTI 2001
G. Bartolozzi Casti, "Il sarcofago dei Maccabei e gli altari sarcofago dei Ss. Apostoli e dei Ss. Cosma e Damiano", in *Atti della Pontificia Accademia Romana di Archeologia. Rendiconti,* 72 (1999-2000), publ. 2001, pp. 177-209.

BARTOLOZZI CASTI 2002
G. Bartolozzi Casti, "Nuove osservazioni sulle basiliche di San Pietro in Vincoli e dei Santi Giovanni e Paolo. Relazioni strutturali, proposte di cronologia, in

"Ecclesiae Urbis", *Atti del Congresso internazionale di studi sulle chiese di Roma (IV-X secolo)* (Rome, September 4-10 2000), II, Vatican City 2002, pp. 953-977.

BARTOLOZZI CASTI 2003-2004
G. Bartolozzi Casti, "La diffusione del culto dei vincoli di Pietro e lo speciale rapporto con Pavia. Indagine riflettometrica sul mosaico di s. Sebastiano", in G. Bartolozzi Casti - M.T. Mazzilli Savini, *Il culto parallelo a s. Sebastiano nelle chiese di S. Pietro in Vincoli di Roma e di Pavia,* in *Atti della Pontificia Accademia Romana di Archeologia. Rendiconti,* 76 (2003-2004), pp. 346-393.

BARTOLOZZI CASTI 2004
G. Bartolozzi Casti, "Le trasformazioni di un complesso edilizio urbano: San Pietro in Vincoli", in L. Paroli - L. Vendittelli (cur.), *Roma dall'Antichità al Medioevo,* II, *I contesti tardoantichi e altomedievali,* Milan 2004, pp. 380-389.

BARTOLOZZI CASTI 2005
G. Bartolozzi Casti, "Restauri medievali e ipotesi sui mosaici originari paleocristiani in S. Pietro in Vincoli", in *Palladio,* 36 (2006), pp. 5-24.

BARTOLOZZI CASTI - ZANDRI 1999
G. Bartolozzi Casti - G. Zandri, *San Pietro in Vincoli,* Roma 1999 (*Le chiese di Roma illustrate,* n.s. 31).

BELLORI 1672
G.P. Bellori, *Le vite de' pittori, scultori, architetti moderni,* I-II, edited by E. Borea - G. Previtali, Cles (Trent) 2009.

BENZI 1990
F. Benzi, *Sisto IV Renovator Urbis. Architettura a Roma 1471-1484,* Rome 1990.

BUZZETTI - COLINI 1963-1964
C. Buzzetti - A.M. Colini, "Il Fagutale e le sue adiacenze nell'epoca antica", in *Atti della Pontificia Accademia Romana di Archeologia. Rendiconti, 36 (1963-1964),* pp. 75-91.

CAGLIOTI 1991
F. Caglioti, "Mino da Fiesole, Mino del Reame, Mino da Montemignaio: un caso chiarito di sdoppiamento d'identità artistica", in *Bollettino d'arte,* 67 (1991), pp. 19-86.

CAGLIOTI 2005
F. Caglioti, "La cappella Piccolomini nel duomo di Siena da Andrea Bregno a Michelangelo", in A. Angelini (ed.), *Pio II e le arti. La riscoperta dell'antico da Federighi a Michelangelo,* Cinisello Balsamo 2005, pp. 387- 481.

CASTROVINCI 2004-2005
R. Castrovinci, *Le decorazioni della sacrestia di s. Pietro in Vincoli,* Unpublished dissertaion, Università degli Studi di Roma "La Sapienza", Academic Year 2004-2005.

CASTROVINCI 2007
R. Castrovinci, "La sacrestia di S. Pietro in Vincoli, Polidoro da Caravaggio e Vincenzo Tamagni", in *Storia dell'Arte,* 118 (2007), pp. 9-30.

CASTROVINCI 2009
R. Castrovinci, *San Sebastiano "depulsor pestilitatis",* in un'incisione inedita di

Dominique Barrière, in «Rolsa. Rivista online di Storia dell'Arte», 11 (2009), pp. 49-67.

CAVALLARO 2000
A. Cavallaro, "Le portelle di S. Pietro in Vincoli, in Sisto IV. Le arti a Roma nel primo Rinascimento", *Convegno Internazionale di Studi* (Rome October 23 - 25 1997), Rome 2000, pp. 399-410.

CBCR
R. Krautheimer, *Corpus basilicarum christianarum Romae (sec. IV-IX),* I-V, Vatican City 1937-1980.

CHASTEL 1989
A. Chastel, *La grottesca,* Turin 1989.

CHAVASSE 1958
A. Chavasse, *Le sacramentaire Gélasien* (*Vaticanus Reginensis 316*), Paris-Tournais 1958.

COLINI - MATTHIAE 1966
A.M. Colini - G. Matthiae, *Ricerche intorno a S. Pietro in Vincoli,* in *Atti della Pontificia Accademia Romana di Archeologia. Memorie,* IX, II, Vatican City 1966.

COLONNA 2004
S. Colonna (ed.), *Roma nella svolta tra Quattro e Cinquecento,* Atti del Convegno Internazionale di Studi, Roma 2004.

CRETI 2002
L. Creti, *I "Cosmati" a Roma e nel Lazio. Il ruolo dei marmorari romani nell'architettura tardomedioevale,* Rome 2002.

CURZI 1998
G. Curzi, "I mosaici dell'oratorio di S. Venanzio nel battistero Lateranense: problemi storici e vicende conservative", in *Atti del V Colloquio dell'Associazione italiana per la storia e la conservazione del mosaico,* (Rome, November 3-6 1997), Ravenna 1998.

DE CASTRIS 2001
P. De Castris, *Polidoro da Caravaggio,* Naples 2001.

DELOGU 2001
P. Delogu, "Il passaggio dall'Antichità al Medioevo", in A. Vauchez (ed.), *Roma medievale* (*Storia di Roma dall'antichità a oggi,* II), Rome-Bari 2001, pp. 3-40.

DE ROSSI 1876
G.B. de Rossi, "Scoperta d'un sarcofago colle reliquie dei Maccabei nella basilica di S. Pietro in Vincoli", in *Bullettino d'Archeologia Cristiana,* 3, 1 (1876), pp. 73-75.

DE TOLNAY 1945-1960
Ch. De Tolnay, *Michelangelo,* I-V, 1945-1960 (IV, *The Tomb of Iulii II: The 1525-1526 Projet*).

DRAGHI 2002
A. Draghi, "La Chiesa di San Pietro in Vincoli. Il restauro degli affreschi di Jacopo Coppi nel catino absidale: un episodio della lotta all'iconoclastia con con-

notazioni Antiebraiche", in G. Capitani - S. Rezzi (eds.), *Architettura e Giubileo a Roma e nel Lazio. Gli interventi di restauro a Roma nel Piano per il Grande Giubileo del 2000*, Naples 2002, pp. 40-51.

DRAGHI - VIOLA 2003a
A. Draghi - R.M. Viola, *Restauro del monumento sepolcrale di papa Giulio II*, in *San Pietro in Vincoli di Michelangelo Buonarroti*, Rome 2003.

DRAGHI - VIOLA 2003b
A. Draghi - R.M. Viola, "La sepoltura di Giulio II: nuove acquisizioni dal restauro", in *MdiR monumentidiroma*, 1/1 (gennaio-giugno 2003), pp. 11-18.

ECHINGER MAURACH 2003
C. Echinger Maurach, "Michelangelo's monument for Julius II in 1534", in *Burlington Magazine*, CXLV (2003), pp. 336-344.

ECHINGER MAURACH 2009
C. Echinger Maurach, *Michelangelos Grabmal für Papst Julius II*, Munich 2009.

FELLETTI MAJ 1950
B.M. Felletti Maj, "Roma. Scuola di Ingegneria, Piazza S. Pietro in Vincoli", in *Notizie degli scavi di antichità* (1948), pubbl. 1950, pp. 308-319.

FERRUA 1939
A. Ferrua, "Dei primi battisteri parrocchiali e di quello di S. Pietro in particolare", in *La civiltà cattolica*, 90-2 (1939), pp. 146-157.

FORCELLINO 2002
A. Forcellino, *Michelangelo Buonarroti. Storia di una passione eretica*, Piacenza 2002.

FORCELLINO 2009
M. Forcellino, *Michelangelo, Vittoria Colonna e gli "spirituali". Religiosità e vita artistica a Roma negli anni Quaranta*, Rome 2009.

FROMMEL 1977
C.L. Frommel, "Cappella Iulia: die Grabkapelle Papst Julius' II in Neu-St. Peter", in *Zeitschrift für Kunstgeschichte*, 4 (1977), pp. 27-72.

FROMMEL 2001
C.L. Frommel, "Il Mosè di Michelangelo e la Tomba di Giulio II in San Pietro in Vincoli", in *Mosè: conflitto e tolleranza intorno al Mosè*, Symposium held at the Accademia di San Luca (Rome, October 4-6 2001). The text may be consulted for a certain period online.

FRUTAZ, *Piante*
A.M. Frutaz, *Le piante di Roma*, I-III, Rome 1962.

FRUTAZ 1981
A.P. Frutaz, *Basilica di S. Pietro in Vincoli*, Rome 1981.

FUR
R. Lanciani, *Forma Urbis Romae*, Mediolani 1893-1901 (Rome 1990)

GALLO 2007
M. Gallo, "La 'santa Margherita di Antiochia ammansisce il drago con la croce' (1644) nella cappella Silvestri in San Pietro in Vincoli, e il suo committente, l'Abate Tommaso

Menzio di Roma", in *Studi di Storia dell'arte. Iconografia e iconologia. La Biblioteca del curioso*, Rome 2007, pp. 211-230.

GIAMPAOLI 1884
L. Giampaoli, *Memorie delle S. Catene di S. Pietro Apostolo. Dissertazione del Ch. Abate Michelangelo Consacrati*, Prato 1884.

GUGLIELMI 1992
D.P. Guglielmi, *I Canonici Regolari Lateranensi. La vita comune nel clero*, Vercelli 1992.

GUIDOBALDI 1986
F. Guidobaldi, "L'edilizia abitativa unifamiliare nella Roma tardoantica", in A. Giardina (ed.), *Società romana e Impero tardoantico*, II, *Roma: politica, economia, paesaggio urbano*, Rome-Bari 1986, pp. 165-237.

GUIDOBALDI - LALLI - PAGANELLI - ANGELELLI 2004
F. Guidobaldi - C. Lalli - M. Paganelli - C. Angelelli, *San Clemente. Gli scavi più recenti (1992-2000)*, in L. Paroli - L. Vendittelli L. Paroli - L. Vendittelli (cur.), *Roma dall'Antichità al Medioevo*, II, *I contesti tardoantichi e altomedievali*, Milan 2004, pp. 390-415.

ICUR
G.B. de Rossi, *Inscriptiones christianae urbis Romae VII saeculo antiquiores*, I-II, 1, Romae 1857-1888.

INFESSURA
Diario della città di Roma di Stefano Infessura scribasenato, edited by O. Tomassini, Rome 1890.

JOANNIDES 1996
P. Joannides, "An overlooked Guercino looked over: the place of St. Augustine in the artist's Oeuvre", in *Apollo*, 143 (1996), pp. 18-19.

KIRSCH 1918
J.P. Kirsch, *Die römischen Titelkirchen in Altertum*, Paderborn 1918.

KRAUTHEIMER 1957
R. Krautheimer, "Il transetto nella basilica paleocristiana", in *Actes du Ve Congrès Internationale d'Archéologie Chrétienne* (Aix-en-Provence, 1954), Vatican City-Paris 1957.

KULTZEN 1968
R. Kultzen, *Die Malereien Polidoros an der Fassade von San Pietro in Vincoli*, in *Festschrift Ulrich Middeldorf*, Berlin 1968, I, pp. 263-268.

LOTTI 1972
L. Lotti, "San Pietro in Vincoli", in *Alma Roma. Bollettino d'informazioni*, 13 (1972), pp. 25-41.

LUCCICHENTI 1982
F. Luccichenti, *Menabò per una storia organaria romana ossia L'Autorità dell'Ipse dixit*, special issue of *Amici dell'organo di Roma*, serie II (1982).

MATTHIAE 1957
G. Matthiae, "Basiliche paleocristiane con ingresso a polifora", in *Bollettino d'Arte*, 42 (1957), pp. 107-121.

MATTHIAE 1987
G. Matthiae, *La pittura italiana del Medioevo nei secoli IV-IX* , edited by M. Andaloro, I, Rome 1987.

MICHELI 1982
M. E. Micheli, *Giovanni Colonna da Tivoli - 1554*, in *Xenia. Quaderni*, 2, Rome 1982.

MORRICONE MATINI 1980
M.L. Morricone Matini, *Scutulata pavimenta - I pavimenti con inserti di marmo e di pietra trovati a Roma e nei dintorni*, Roma 1980.

NAPOLETANO 2009
A. Napoletano, "Preesistenze medievali nell'area di Palazzo Silvestri-Rivaldi", in *Ricerche di Storia dell'Arte*, 97 (2009), pp. 7- 16.

PANI ERMINI 1992
L. Pani Ermini, "Roma tra la fine del IV e gli inizi del V secolo", in G. Sena Chiesa - E.A. Arslan (ed.), "Felix temporis reparatio 'Roma capitale dell'Impero Romano'", *Atti del Convegno* (Milan, March 8-11 1990), Milan 1992, pp. 193-202.

PAOLUCCI 1932
A. Paolucci, "Di una porta lignea scolpita nella sagrestia di San Pietro in Vincoli in Roma", in *Roma*, 10 (1932), pp. 25-32.

PAPILLO 2003
G. Papillo, "Il rilievo come contributo critico per la lettura del monumento funebre", in *MdiR monumentidiroma*, 1/1 (January-June 2003), pp. 19-28.

PG
Patrologiae cursus completus. Series graeca, I-CLXI, edited by J.-P. Migne, Parisiis 1857-1866.

PIETRI 1989
Ch. Pietri, *Régions écclesiastiques et paroisses romaines*, in *Actes du XIe Congrès international d'Archéologie chrétienne* (September 21-28 1986), II, Vatican City 1989, pp. 1035-1062.

PL
Patrologiae cursus completus. Series latina, I-CCXXI, edited by J.-P. Migne, Parisiis 1844-1864.

PULINI 2003
M. Pulini, "I cinque sentimenti del Guercino", in D. Mahon - M. Pulini - V. Sgarbi (ed.), *Guercino Poesia e Sentimenti nella Pittura del Seicento* (Milan Palazzo Reale, September 27, 2003 – January 2004), *Orio al Serio* 2003, pp. 67-82.

ROIO 2011-2012
E. Roio, *Il palazzo cardinalizio di San Pietro in Vincoli a Roma: dagli studi storici al progetto di restauro e valorizzazione*, Unpublished dissertation in architecture (restoration), Università di Roma "La Sapienza", supervisor Prof. arch. Nicola Santopuoli, Academic year 2011-2012.

SALERNO 1988
L. Salerno, *I dipinti del Guercino*, Rome 1988.

SANSONI 1998
U. Sansoni, *Il nodo di Salomone. Simbolo e archetipo di alleanza*, Milan 1998.

SAXER 1989
V. Saxer, "L'utilisation par la liturgie de l'espace urbain et suburbain: l'exemple de Rome dans l'antiquité et le haut moyen âge", in *Actes du XI^e Congrès international d'Archéologie chrétienne* (September 21-28 1986), II, Vatican City 1989, pp. 918-1033.

SBAPR
Soprintendenza ai Beni Architettonici e Paesaggistici per il Comune di Roma.

SCIOLLA 1970
G.C. SCIOLLA, *La scultura di Mino da Fiesole*, Turin 1970.

SPEAR 1982
R. Spear, *Domenichino*, I, New Haven-London 1982, pp. 133-134.

STRINATI 1979
C. Strinati (ed.), "Quadri romani fra Cinquecento e Seicento. Quadri restaurati e da Restaurare", Catalogue of the Exhbition (Rome, Palazzo Venezia, Janaury 29 - March 28 1979), Rome 1979, pp. 15-16.

TITI 1721
F. Titi, *Nuovo Studio di Pittura, Scoltura et Architettura nelle Chiese di Roma, Palazzi Vaticani, di Monte Cavallo & altri,* Rome 1721, anastatic reprint, Sala Bolognese 1974.

TRITZ 2008
S. Tritz, *"...uns Schätze im Himmel zu sammeln". Die Stiftungen des Nikolaus von Kues*, Trier 2008.

TROMBELLI 1752
G.C. Trombelli, *Memorie istoriche concernenti le due canoniche di S. Maria di Reno e di S. Salvatore insieme unite*, Bologna 1752.

TOMASSETTI, *La campagna romana*
F. Tomassetti, *La campagna romana antica, medievale e moderna,* I-IV, Rome 1910-1926 (new edition edited by L. Chiumenti - F. Bilancia, I-VII, Florence 1975-1980).

UGONIO 1588
P. Ugonio, *Historia delle Stationi di Roma che si celebrano la Quadragesima*, Rome 1588.

VASARI 1568
G. Vasari, *Le vite de' più eccellenti pittori scultori et architetti* (1568), integral edition, Introduction by M. Marini, Milan 1993.

VENANZI 1953
C. Venanzi, *Caratteri costruttivi dei monumenti. Strutture murarie a Roma e nel Lazio* (Centro di studi per la Storia dell'architettura, Rome), Spoleto 1953.

VENDITTELLI 2004
L. Vendittelli, "Le produzioni di lusso, l'abbigliamento e l'ornamento a Roma in epoca tardo-antica e altomedievale:, in D. Candilio (ed.), *Moda costume e bellezza nella Roma antica,* Milan 2004, pp. 69-80.

WS
J. Wilpert, *I sarcofagi cristiani antichi,* I-III, Rome 1929-1936.

ZANDER 2010
P. Zander, *Il ciborio degli Apostoli,* Vatican City, 2010 ("Archivum Sancti Petri", *Bollettino d'archivio* 15-16).

ZANDRI 1998
G. Zandri, "Il complesso conventuale di S. Pietro in Vincoli: nuove acquisizioni", in *Archivio della Società Romana di Storia Patria,* 121 (1998), pp. 91-118.

ZANDRI 2000 a
G. Zandri, "Sull'altare delle Sacre Catene e sulla tomba di Nicola Cusano in San Pietro in Vincoli", in *Studi Romani,* 48 (2000), pp. 118-125.

ZANDRI 2000 b
G. Zandri, "Francesco Fontana e il soffitto di San Pietro in Vincoli", in *Storia dell'Arte,* 100 (2000), pp. 123-144.

Finito di stampare nel mese di dicembre 2014
presso la CDC Arti Grafiche, Città di Castello (Perugia)